Art of the Thirties

Index of Art in the Pacific Northwest

Art of the Thirties
The Pacific Northwest

By Martha Kingsbury

Published for the Henry Art Gallery
by the University of Washington Press
Seattle and London

Art of the Thirties was prepared as a catalogue for an exhibition held at the Henry Art Gallery, University of Washington, April 1–30, and at the Portland Art Museum, Portland, Oregon, May 24–June 25, 1972.

Library of Congress Cataloging in Publication Data

Kingsbury, Martha, 1941-
 Art of the thirties.

 (Index of art in the Pacific Northwest, v. 4)
 Catalog for an exhibition held at the Henry Art
Gallery, University of Washington, April 1972.
 Bibliography: p.
 1. Art—Northwest, Pacific. 2. Art, Modern—20th
century—Northwest, Pacific. I. Henry Art Gallery. II.
Title. III. Series.
N6528.K5 709'.795 72-1111

ISBN 0-295-95215-6
ISBN 0-295-95246-6 (pbk.)

Foreword

This is the fourth volume in the series Index of Art in the Pacific Northwest and the first of the project to document the history of art in the Pacific Northwest. There are several reasons for beginning with the decade of the thirties. It was a period of great activity and self-awareness in the arts in this region. Northwest artists were beginning to achieve recognition on a national level. It was a crucial time for the assimilation of influences and the growth of individual purposes. Foundations were laid for future development. And the decade itself, conveniently defined by the Great Depression at the beginning and the Second World War at the end, had a certain unity.

The art of the thirties is often poorly remembered or, equally often, not remembered at all. Freud once remarked to a friend, "Never trust a man who doesn't remember his childhood." It is the purpose of this study to document this period, to trace the origins of more recent developments, to reassess the contributions of the time, and to reacquaint ourselves with our past. Martha Kingsbury, a newcomer to the Northwest, has approached the subject with a fresh eye and a formidable sense of history. She has traced esthetic, political, and economic influences on an area that sought regional maturity and aspired to participation in the international art scene. It is a vivid and sometimes sentimental encounter with the past.

Future volumes in this documentation of Northwest art are planned to treat the decades that followed—the forties, the fifties, and the sixties—as well as the work of individuals who have won or deserve wider recognition. Eventually, it is hoped, the series will provide a complete history of the art of the Pacific Northwest.

Special thanks are due to the Pacific Northwest Arts Center and its board of trustees for a grant that contributed toward the production of this book.

Spencer Moseley
Acting Director, Henry Art Gallery
Director, School of Art

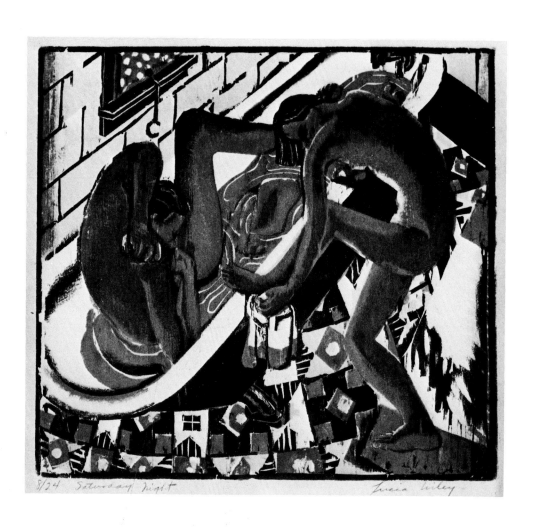

8/24 Saturday Night Lucia Wiley

(90) Lucia Wiley. *Saturday Night*

Acknowledgments

I wish to express my gratitude to the many individuals who generously lent not only works for the exhibition but their time and memories as well. Jean Ashford, Carl Gould, Jr., Dick McCann, Viola Patterson, Ruth Penington, Terry Pettus, George Tsutakawa, and the late Marcus Priteca should be mentioned in particular. For assistance with background research and in locating material, I owe thanks to graduate students in my seminars during the winter and spring of 1971. Staff members of institutions from whom we borrowed extensively have been very helpful: especially I may mention Rachael Griffin of the Portland Art Museum; Pauline Adams and Sarah Clark of the Seattle Art Museum; Virginia Reich of the Seattle Public Library; Robert Monroe of the University of Washington Library; Robert Lussier of the Museum of History and Industry, Seattle; Darryl Sewell of the National Collection of Fine Arts, Washington, D.C.; and Charles Rhyne of Reed College. LaMar Harrington and the rest of the Henry Gallery staff have been crucial to the success of the exhibition.

I also wish to convey my appreciation to those who have helped with the book, in particular William Eng, Alfred Monner, Stanley Hess, and Earl Fields for photographs. Spencer Moseley, director of the University of Washington School of Art, has freely contributed ideas, advice, and encouragement throughout. And for special assistance at numerous points, I extend my thanks to Ronda Skubi, Jane Furchgott, Charles Munch, and David Munch. The aid of these and many other individuals in calling my attention to artists and works has been crucial, but responsibility rests with me for interpretation of the situation and for any mistakes, inadvertent omissions, or unexpected inclusions.

Martha Kingsbury

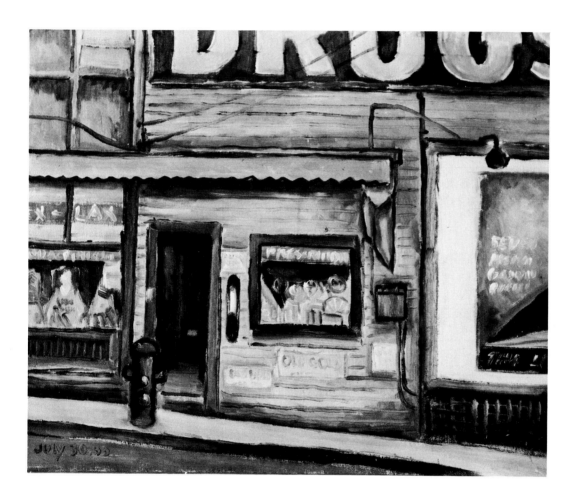

(40) Kamekichi Tokita. *Drugstore*

This essay and the exhibition it accompanies are devoted to the art of the Pacific Northwest in the 1930s. It concentrates on the Puget Sound area, but includes examples from Oregon and central Washington. A few works from outside the area or the decade are included when their style and the fact of their acquisition make them particularly representative of taste or esthetic influences at the time. The primary aim is to rediscover the breadth and quality of artistic efforts in the region. But the maturity and complexity of the area's art were sufficiently great, and the awareness of esthetic currents in the rest of America and Europe was so lively, that the situation in this limited region was to a significant extent representative of conditions in the United States in general. Thus the region's art has become a focus for considering the meaning of "regionalism" in the thirties. This concept was much in the air then, and it is of additional interest in this case since many believe that a "Northwest School" emerged on the national art scene in the following decade. Related to this issue, of course, are the questions of what characterized art in the thirties in general, and of what were the relationships between ostensibly very different artistic currents during this period.

The geographic limits of the area were sharply defined then as now. Portland and Seattle faced the sea psychologically, with their backs to the interior. Artists in the region thought of art and culture as available by water; San Francisco was the nearest hive of activity (by passenger boat from Seattle) and, beyond that, was Paris. What went on "across the mountains," east of the Cascades, was of less importance to the cities' artists. The chronological boundaries of the era are also clearly determined. It is true that the period between the wars had much continuity; and some artistic movements (such as Surrealism) and stylistic trends (such as the recently rehabilitated Art Deco) pertain to that whole period. But particularly in the United States the decade of the thirties was an era sharply distinguished by events that significantly altered conditions for the creation of art: the stock market crash at the beginning and the Second World War at the end.

The art of this decade exhibits a great diversity—so great in some ways that a reconciliation might seem impossible. The chasm between grimly serious social realism and aggressively geometric ornament appears unbridgeable. Since this investigation attempts to rediscover the full range of artistic currents at the time, apparently contradictory tendencies are included. To make sense of their simultaneous development is not so totally impossible as it might at first seem, for the most paradoxical juxtapositions may be resolved if the works are understood as opposite sides of the same coin. That crucial coin, at least for the United States, was, of course, the Great Depression. Austere styles and grim subjects appeared in works by artists who conscientiously considered the hard times, while extravagant stylizations and witty inventions were concocted by artists who worked equally hard to escape the depression mood. Traditionally serious media such as painting and sculpture were frequently used both to document the era and to embody ideal alternatives to its disturbing reality. Objects for embellishing the house, fashions for embellishing the figure, and art associated with entertainment more frequently escaped into lighter realms of humor and fantasy. Of course any medium could be devoted to either purpose, and printmaking and architecture in particular were often developed in both directions. From the great variety of works of the time, one overall impression emerges with greatest certainty: that of the vitality of art in the Northwest by the 1930s.

The Northwest in the 1930s

Until the 1930s the Northwest, culturally, was practically pioneering territory. Even its economic structure was only a few generations old by that decade. (Seattle's population, for example, was only about eighty thousand in 1900 after the Alaskan gold rush had augmented it; that number had more than quadrupled by 1930.) Many of the area's cultural institutions were still newer. Portland had had an art association, with regular exhibitions and a permanent collection as its goal, since the turn of the century, and by 1910 the Portland Art Association had both a building and a museum school. Since 1906 Seattle had had the Seattle Fine Arts Society, which became the Art Institute of Seattle but remained for many years without its own permanent facilities.

By 1930, however, art had become a recognized permanent fixture in both cities. Horace C. Henry donated his collection (mostly nineteenth-century landscape paintings) and a building to house it to the University of Washington in Seattle in 1926; the Portland Museum moved to its present permanent quarters in 1931; and in 1933 the Seattle Art Museum opened, providing a permanent focus for the activities of the Art Institute of Seattle. By this time the University of Washington's art program was also well established, with about a dozen faculty members. Thus, by the 1930s in both cities a person could view art on a regular basis and could also elect to receive regular instruction in artistic matters. By this time also —but scarcely before—a young person could aspire to become an artist on home ground with some real chance of success; and the basis for expanding and diversifying artistic activity was laid.

In 1930 there were also several associations through which artists sought recognition by each other and by the public with meetings and exhibitions. Seattle's Northwest Annual Exhibitions had begun in 1916 and were held at the Seattle Art Museum after it was built; the Seattle Camera Club had exhibited annually since it was formed in 1925; and the Northwest Print Makers, organized in 1928, exhibited annually from 1929. Even state fairs had art sections where, as esthetic consciousness changed, the juries were sometimes forced to award double prizes, in "modern" and in more traditional art. Throughout the decade, advocates such as the painter Kenneth Callahan exerted great energy through reviews and articles in local papers and national periodicals on behalf of Northwest art—for more awareness of it and more quality in it, and for a sense of regional pride.

Several paradoxes result from the fact that the Northwest's cultural coming-of-age took place when it did. Most obviously, the area had just developed to the point of having both artists and audiences interested in viewing and acquiring art when the depression intervened and nearly squelched many developments. Another paradox is that many of the area's younger artists became knowledgeable about contemporary art at a national and international level just at a time when regionalism was being strongly emphasized everywhere. And a related irony is that a professional attitude and an understanding of the narrower tradition of European "Fine Arts"—painting, sculpture, and architecture—became possible for many just at a time when the definition of art was being broadened beyond its former confines to include means and media not formerly admitted. Some consideration of the broader situation within which Northwest art blossomed in the late 1930s will make these paradoxes clearer.

Government Programs

By the mid-thirties, the depression had led to a unique situation all over the United States for the creation of art, in the form of several government programs for the support of artists. The assumption behind such programs—that art ought not be allowed to disappear in times of crisis, and that an artist, like any other tradesman or professional, ought not to allow his special skills to lapse—agreed with widely expressed demands in an area like New York City, where hundreds of artists already worked, and where the exhibition and collection of art were accepted activities. But in many of the smaller towns and in more recently developed regions, where art as either product or activity was scarcely visible at all, the government's patronage and concern must have brought a new air of authority to demands that art be considered part of society's fabric.

The government programs provided several kinds of support for the visual arts. The Public Works of Art Project (PWAP) was set up as early as 1933, under Edward Bruce. Artists were instructed to stress the "American scene" in their subjects, and experiment was not encouraged, but in spite of this, and though the program was short-lived, its encouragement of local artists had a great impact. Addressing an annual meeting of the Pacific Arts Association in June 1934, its president Walter Isaacs said that, since the last meeting, "There has taken place in America what one is tempted to call the most significant change in our art history. I refer to the Public Works of Art Project."

From 1934 into the early forties, Bruce directed programs providing art in public buildings, funded by the Treasury Department. These programs aimed at

the highest available quality of decoration. Competitions were announced for particular sites, and commissions were awarded on the basis of sketches and proposals submitted to a jury, rather than on the basis of need (although need was sometimes a factor for small commissions or for hiring of assistants). Juries were typically composed of artists and museum personnel, often from the area of the commission in smaller competitions, or of national stature when new buildings in Washington, D.C., were in question. Many established artists, fired by the example of Mexican muralists (particularly Diego Rivera and José Orozco) and excited by the prospect of reaching a wide public with powerful large-scale works, were eager to participate in the program.

Through such programs a number of public buildings received mural decorations by Northwest artists. Examples are David McCosh's *Incidents in the Lives of Lewis and Clark* in the Kelso post office, Jacob Elshin's two panels embodying past and present learning in the University Way post office in Seattle, and his *Miners at Work* in Renton. Treasury art projects in Washington post offices also included murals by Ernest Norling in Prosser and Bremerton, by Ambrose Patterson in Mt. Vernon, and by Kenneth Callahan in Centralia. In many places these were the first significant art works available to the public on a regular basis, and they were often the first art to concern itself directly with the lives or history of their particular public. The view that art ought to be part of everyone's life was exemplified both by the fact of government support and also by the subjects and the placement of much of the resulting art. Some of the programs encouraged administrators or artists to enlist the support of patrons within the community (businesses that would donate mural space or materials, for example) in the hope of directly involving the local public at all levels and of integrating art more fully with local life.

In 1935 the WPA (Works Progress Administration, later Work Projects Administration) set up a Federal Art Project directed by Holger Cahill. This persisted in various forms until 1943. In contrast to most of the Treasury Department's programs, these projects were administered at the state and regional level and supported local artists on the basis of need. Robert Bruce Inverarity in Seattle headed the Washington project, which was included in region 16, directed from Portland. An artist who demonstrated his need and his artistic training or skill was admitted to the WPA rolls and typically received a small salary in exchange for an agreed-upon number of his works. The pay was in the range of ninety dollars a month, and the number of works was based on the artist's manner and speed of working—for example, an easel painting every few weeks. No one became rich or famous directly through this program, but artists in areas like the Northwest received two very valuable benefits: the recognition and status of having a respected profession and the encouragement that implicitly went with that; and, more practically, the time and materials made available by the paycheck, which enabled them to persist in their art. Works acquired by the government through such programs were occasionally sold, but more often were deposited with public institutions as permanent loans. The Seattle Art Museum has a number of paintings and prints acquired in this manner, as does the Henry Gallery, and the Portland Museum has a large collection of prints including many from the New York and California projects. Eventually some WPA works were destroyed for lack of interest or storage space.

The results of the WPA projects were often less spectacularly visible to the public than were those of the Treasury Department programs. Their main effect was the encouragement and freedom they gave to artists. Nevertheless, certain WPA projects were more public in nature. For example, art centers were set up under the direction of practicing artists in areas where there had previously been no art facilities of any sort. The Spokane Art Center was a notable example. Set up in 1938 under the direction of the painter Carl Morris, it combined the functions of a museum and a school. Classes in drawing and painting for both adults and children were held, and traveling exhibits were mounted. Hilda Deutsch, Guy Anderson, and Vanessa Helder were among the artists who helped with the Spokane art center.

Another WPA project intended to be publicly visible eventually was the Index

of American Design. This was a nationwide program, coordinated through the regional directors, to record the wealth of American folk design and indigenous products. A meticulous technique of color rendering (usually but not always watercolor) was developed to capture the full character as well as the minute details of such objects as weather vanes, quilts, and rocking chairs. The project employed local artists, but the results were gathered together and are now in the National Gallery in Washington, D.C. Eventual publication was the original aim, and partial publication was achieved in 1959 with Erwin O. Christensen's *The Index of American Design.* At least five Washington artists worked on the index, recording among other things a large collection of piggy banks.

In the Northwest, the support and recognition of artists by these government programs and the visibility of art in post offices and other public buildings very nearly coincided with the flowering of artistic activity in newly founded private association and museums. Undoubtedly, the government's support reinforced the new image of art as something not only desirable but actually possible. In many instances, also, the help of these public programs to the younger artists was probably crucial at a time when the area's recently founded institutions must have been seriously threatened by the economic situation. For though the schools and museums loyally hired artists as curators and assistants of various sorts, they could support only a few, and there was little market for art.

Esthetics and Taste

Specific styles of art in the thirties can best be dealt with in terms of their Northwest practitioners, but certain general tendencies underlying these diverse styles and their particular implications for the Northwest can be noted here.

From the theory and criticism of art as well as from the art itself one can sense a very great earnestness in the 1930s and an overlapping of esthetic and moral values. Goals like progress, modernism, efficiency, and practicality were discussed with reference to such newer areas of art as industrial design. These neo-ethical standards or goals were subtly but pervasively present in the more traditional art forms also. Architecture, for example, was expected to embody purity and honesty (either in an objective general form, as truth, or in a subjective individual manner, as integrity). In specific terms, these ideals might dictate honesty or integrity by an adherence to some condition external to the artist. For example, the social realists felt bound to be faithful to their subject matter. They might variously interpret this as a duty to document correctly, to protest selected facets, or to idealize other selected aspects of contemporary reality. Many architects and designers intended their art to reflect truly the conditions of contemporary life (be modern rather than historicist), and designed their products for wide use and cheap acquisition by many. The influence of the Bauhaus in Germany through the twenties, and the emigration to the United States in the thirties of many of its leading artists, spread this esthetic. Even before they arrived, their influence was felt through such publications as Henry-Russell Hitchcock and Philip Johnson's *The International Style: Architecture since 1922* (1932), and through the personal interest of such individuals as Walter Isaacs who, as director of the University of Washington School of Art, developed programs that stressed design as well as painting and sculpture.

Other interpretations of such esthetic-moral attitudes insisted that the artist must be honest in his adherence to something intrinsic in himself or his intended audience. When the artist concerned himself with truth to his or his viewer's roots, through either his subject matter or his style, the result tended toward the regionalism that was so important a concern by the latter part of the decade. The Index of American Design was based in part on this intense loyalty to America's recently discovered past. (The twenties had seen, along with isolationism in politics, a strong interest in America's indigenous culture. Holger Cahill had been concerned with American folk design in the twenties before he came to the WPA project.) Many artists, on and off the projects, were sympathetic to these aims, which after all bolstered their own confidence and self-respect. The local subjects of many post-office murals are products of this attitude. So was Inverarity's pride that one of the artists under him on the project, Julius Twohy, was an American

Indian of the Ute tribe who abandoned a conventional European manner and returned to the symbols and styles of his own people.

An even more esthetically intrinsic interpretation of the moral demand for truth in art was that the artist must preserve the integrity of his medium or his material. This appears to have been a widespread if often unstated assumption. It decreed that the best motifs for sculpture, since that medium is pre-eminently three-dimensional, were the most massive or the bulkiest. Painting, in contrast, is basically and essentially two-dimensional. Thus, no matter how "realistic" the subject or how seemingly conservative the retreat from avant-garde styles of previous decades, the predominantly two-dimensional character of painting was widely respected in the thirties. The nineteenth-century varieties of illusionism and trompe l'oeil painting never returned; objects and figures were restructured on the painting's surface, and an artist's concern was with the composition of that surface. Various schemes for attaining satisfactory proportions and interrelations within the surface were widely disseminated, and many works of the era contained an underlying system of intersecting diagonals or some other ordering principle.

Visually, Cézanne, the Cubists, the German Expressionists, and the Italian Futurists provided the basis of most works. Joseph Stella's *Factories at Night* is an outstanding example that illustrates both his futurist influences and his development in the thirties. Intellectually, such theorists of the previous decades as Arthur W. Dow and Jay Hambidge provided what appeared to be coherent formulations of organizing principles. The former's book, *Composition,* emphasized an intuitive feeling for the proportions of a surface, exemplified by many examples of Asian art; the latter's books, such as *Dynamic Symmetry,* promulgated a mathematical order based on Greek examples. The era saw the full development of that approach which considered art in terms of *balance,* and of the practice of superimposing diagrammatic guides over compositions in order to analyze how various "movements" had been "balanced." (Perhaps even the diagonal hems and bold, slashing diagonal lines of fashion design owed something to this same esthetic.)

Prints, like painting, were perceived as two-dimensional in essence and were composed on the same principles. In addition they reflected a concern for specific techniques. Block prints were usually hacked and chopped to emphasize the block and the technique of cutting, after the style of the German Expressionists. Lithographs, conversely, were soft and muted, with frequent use of their capacity for perfectly regulated gradation of tone. Etching and drypoint frequently tended to be, by comparison, very delicate and spontaneous.

Architecture, then, was to be pre-eminently a matter of sheer planes enclosing volumes of space, since that is what sets it apart from other arts. Embellishment—other than that inherent in the materials and in the basic structure—was regarded as an impurity or, at best, a separate addition. It was often restricted to clearly defined areas, set off from the basic structure. Ornament could be dense and strong (since extravagance is, after all, *its* distinctive trait), but it also remained planar so as not to undercut the severity of the underlying forms.

This intensely moral attitude reconciled some apparently wide divergences in style; for example, great differences between paintings and sculptures resulted from the same view of truth to materials or to medium. Similarly, an analogous earnestness about the purposes of art can be sensed in works as divergent as an expressionist print (earnestly protesting some social evil) and an extravagantly streamlined radio cabinet (earnestly remedying social evils by symbolizing progress in an inexpensive form which the masses would be able to afford). Clarity of distinctions, simplicity, and directness were valued in all media, whether as the means to a publicly significant message or as the means to abstract purity or beauty. Washington's Grand Coulee Dam and other projects like it throughout the nation were perceived as excellent both for their progressive utilitarian implications and for their formal qualities; but these were related, not distinct, aspects, and simple direct forms were believed to embody both the function and the beauty of the work.

Another aspect of the changing esthetic of the thirties was the ever broadening concept of art's nature, origins, and purposes. The subjects and styles at art's core

multiplied. All the avant-garde developments of the previous several decades remained present to some extent, and at the same time conservative (to some minds, reactionary) tendencies were recertified as respectably "modern." During this basically conservative decade, specific subject matter—even local subjects—again became acceptable in Europe as well as in the United States. For example, the most widespread and significant movement to develop through the thirties was probably Surrealism. Like Pop Art later, it was relatively accessible, through its subject matter and its wit, to conservative elements among artists and the public. The temporarily broadened tolerance of a variety of modes as equally up to date allowed Social Realists, hard-edge Geometric Abstractionists, and loose Expressionists to exist side by side within the charmed circle of progressive art. The split between the avant-garde and the academic was harder to determine than formerly (although this did not preclude vigorous disputes between adherents of different approaches). This situation appears in retrospect to have been to the advantage of young artists in outlying areas. They could make a transition to nonrepresentational art through Social Realism, Expressionism, or Surrealism, in a gradual development with lasting results, rather than by breaking entirely with their origins. This was the pattern followed by the young artists who were later known as Abstract Expressionists (Jackson Pollock, or Clifford Still working at Washington State College in Pullman in the thirties) and by many of the best young artists in the Northwest. Perhaps the conservativism of the decade and the partial truce among styles were also to the advantage of art's new audiences in these areas.

Not only did the range of styles and subjects permissible within the core of art broaden, but that core itself was enlarged to include new media and techniques. The Bauhaus, mentioned above as one influence promoting the complex of moral-esthetic values, was also partly responsible for this more liberal view of art. Photography and film making were admitted, with more sureness than formerly, to the museums. The exhibitions of the Seattle Camera Club were local evidence of this change. The inclusion by the New York Museum of Modern Art of such materials in its collections and exhibitions during the decade was parallel evidence on a national level. Printmaking underwent a great revival, much as it had thirty to forty years earlier, perhaps this time partly because it was inexpensive and could be made accessible to many—another sign of the social conscience of the era. Industrial design became widely respected and even glamorous, as it had never been before. Popular American publications like Sheldon Cheney's *Art and the Machine* (1936) and Walter Dorwin Teague's *Design This Day* (1940) exemplified these attitudes. The notion of industry as hope for the economy reinforced the basic democracy of the machine esthetic. Streamlining and machine styling were optimistically adapted to many products, with results that range from classic to comic. New and more practical materials were adopted along with the new forms—plastics, chrome, synthetic fibers in fabrics. Painters experimented with the air brush of the commercial artist much as later artists would adopt car enamel, synthetic pigments, and the spray gun. (Raymond Jonson's Art Deco *Watercolor No. 5* and the souvenir plate and postcards from the 1939 New York World's Fair are examples.)

The origins of true art were also perceived as broader than they had formerly been thought to be. The arts of tribal cultures, folk art, children's art, and even art of the insane had all been patronized by elite groups for two or three decades. By the thirties their acceptance had become more widespread. The esthetic-moral injunction to "be true to thyself" of course reinforced the appreciation of all such forms for their uniqueness rather than for their conformity to any dominant esthetic. Art of the American Indians was particularly satisfying to the era's taste, as exemplified in Julius Twohy's native designs, the pottery that was widely collected, or Walter Shelly Phillips' stylish designs for an *American Indian Primer*.

As the acceptable origins of art were democratically broadened, so were its functions. It was perceived by many as something by and for the people rather than for an elite. There was much disillusionment after World War II when the government programs had evaporated, the example of the Mexican muralists had

faded, piles of WPA paintings were burned, and artists became convinced that the public did not want art after all. But for a time, at least, it was hopefully believed that a sense of form must lie latent in everyone; that the creation of art on some modest scale could be anyone's hobby; and that the appreciation of public art was everyone's right. Again, moral and political beliefs reinforced esthetic concepts, and the heritage of these beliefs is present still.

Regionalism

Some final questions emerge about the relationship of the Northwest to this general situation: what degree of regional consciousness developed in the Northwest then, and what were its visual manifestations? And what was the relation between Northwest art of the thirties and the emergence of a "Northwest School" on the national scene in the following decade? There is no doubt that Kenneth Callahan, among others, called repeatedly for a regional consciousness by Puget Sound artists. The demand was the same as that being made of artists in all parts of the United States, and it undoubtedly helped lay the groundwork for the self-confident and self-conscious developments of the following decades. Basically, of course, it reinforced the twin ideas that an artist need not leave the area for training, inspiration, or patrons, and that patrons need not search elsewhere for art.

But it is not clear that there was much distinction in visual terms by the 1930s between art created in the Northwest and that produced elsewhere in America. Conditions unique to the area may have contributed slightly to promote certain biases (in addition to the gray rainy weather that is often cited as responsible for the somber-hued, introverted character commonly associated with Northwest art). Among factors that might have affected slightly the development of Northwest artists was the absence of many major examples of European art, either in painting or sculpture. The result, as in many other places, was a dependency on travel, on visitors and teachers from elsewhere, and on reproductions for knowledge of other art—thus the significance attached to visits to Seattle by Alexander Archipenko in 1936 and 1937, Amédée Ozenfant in 1938, and Johannes Molzahn in 1940. The generally high quality and wide range of prints might be due in part to the faithfulness with which their small scale and tonal structure could be reproduced. Likewise the often untextured or scabby surfaces and relatively frugal color of paintings might owe something to the absence of good examples. But in fact these same characteristics prevailed in art over the rest of the United States then. They might equally well be due to an emphasis on linear structure over color, and a general de-emphasis of the technical and sensual aspects of art, associated with the brooding moralism of the time. Again, one wonders how much of this attitude was still subtly operative after World War II, in the widespread and deliberate "ugliness" of much innovative art.

Another distinctive factor was the presence of significant Asian art in the Northwest, particularly after the opening of the Seattle Art Museum. Dr. Richard E. Fuller, a geologist, and his mother, Mrs. Eugene Fuller, generously provided funds for the museum and donated their own extensive collection of Asian art as its nucleus. The collection then contained relatively little painting and sculpture, but many examples of exquisite craftsmanship, fine materials, and magnificent design which probably contributed something, as has often been cited, toward the later Northwest esthetic. Among other things the collection, along with the presence of an Asian community and a merchant marine headed regularly for the Orient, encouraged several artists to go there themselves (notably Morris Graves in the merchant marine, several times in the late twenties; and Mark Tobey in 1934, both to China and to Japan to study calligraphy and printing). The examples of Asian art may also have contributed to a crafts tradition that remains very strong. The broadened esthetic of the thirties undoubtedly contributed to this, and so, perhaps, did the frontier tradition of self-sufficiency and of making one's own objects for both use and beauty.

One more factor that might be deduced from Northwest works of the thirties is a spirit of cranky independence (something Northwest citizens, like those of Maine, pride themselves on). The trend toward glorification of a region's basic

activities was not fully met. Logging was condemned as destructive of men and land more often than it was idealized. In many paintings the sea was a melancholy watery waste rather than a teeming harvest field. But criticism of all aspects of America—its cities, farms, industries, and institutions—was frequent everywhere in the nation at the time, and such critical self-examination contributed much to the solemn intensity of works which might otherwise, by their themes, have become sweetly sentimental.

The decade of the thirties may have laid the groundwork for a regional school, but Northwest art was still to a great extent representative of art across the nation —thus the paradox, that artists became regionally conscious just at the point of entry into national and international mainstreams. The experience of the Northwest not only typified the experience of many regions within the country, but also paralleled the experience of American art in general, which was characterized at the time both by relatively conservative visual developments and by independent and self-sufficient attitudes about itself. In the next decade, American art simultaneously entered the international mainstream as an important force and became genuinely free of overdependence on European art; while Northwest art emerged on the national scene without further dependence on developments elsewhere.

Of the artists whose works and careers will be considered in the following sections, an increasing number exhibited outside the Northwest through the thirties. Some of those who originated outside the Northwest had already, of course, exhibited nationally or internationally. For example, Ambrose Patterson had exhibited at the famous Salon d'Automne in Paris from 1903 to 1908 (he was one of its original members), and in 1904 at the Royal Academy in London, as well as on other occasions in Paris, Brussels, and at the Guggenheim Museum in New York. Walter Isaacs had exhibited paintings in the Paris Salons of 1922 and 1923, at the Museum of Modern Art in New York, and at the Golden Gate Exposition of 1939. Mark Tobey had had a one-man show at Knoedlers Gallery in New York as early as 1917 and by 1930 had been included in one of the first Museum of Modern Art shows. By the thirties, more indigenous Northwest art began to be shown elsewhere also. In 1930 groups in San Francisco, Los Angeles, San Diego, and Houston requested paintings from the Northwest Annual for exhibition, and in 1931 thirty works from the Northwest Annual circulated on the East Coast.

Within the decade, individual Northwest artists were recognized nationally. For example, Kenneth Callahan exhibited at the Whitney Museum of Art, the Museum of Modern Art, the 1939 New York World's Fair, the Corcoran Gallery, the 1939 San Francisco International Exposition, and in a national traveling show, among other places. Morris Graves's works were shown at the Corcoran Gallery, the Pennsylvania Academy of Fine Arts, the New York World's Fair, and later the Museum of Modern Art. Peter Camfferman exhibited at the Chicago and San Francisco fairs; Maude Kerns had a show in New York; and Emily Carr's landscapes, often incorporating Indian motifs, were exhibited in the United States and Europe as well as in her native Canada. These works and others were exported from a widening base of energetic and varied artistic activity in the Northwest.

Artists in the Formal Traditions

By 1930 Seattle had been for roughly a decade the home of several painters who had had wide experience and training elsewhere. They brought to the area an awareness of the foundations of twentieth-century art as they had known it earlier abroad. As examples, they were undoubtedly important in easing the transition from art as a conservative matter of likenesses (to people or scenery) to art as an independent restructuring of inner or outer reality.

Ambrose Patterson studied in Paris for over a decade around the turn of the century, financially aided much of this time by the opera star Mme Nellie Melba, who was a distant relative. He arrived in the Northwest in 1918, and in 1929-30 he returned to Paris and studied briefly with André L'Hôte. Patterson traveled extensively in Europe as well as to his native Australia, to Hawaii, and to Mexico,

where he studied fresco painting. Although he had experimented with nonobjective works by the thirties, he usually worked with color and light as the Impressionists had. In addition, he was a sophisticated printmaker in a manner influenced by Japanese color woodcuts.

Walter Isaacs, somewhat younger, had studied in Paris about 1920 and exemplified in his own work the crucial contribution of Cézanne to the structure of twentieth-century painting. It was as a result of his influence, as director of the University of Washington School of Art, that the broadened concepts of the Bauhaus were partly implemented in the Northwest. In the mid-thirties Isaacs introduced into a number of figure compositions small areas of banding or other simple and arbitrary patterning; it is a touch that links his works with both neoclassic and decorative tendencies of the era. But his basic emphasis on structuring an elusive space through relations of warm and cool planes of color on a surface remained solidly within the most basic concerns of modern painting.

Peter and Margaret Camfferman were also painters of maturity by the thirties. They had studied in André L'Hôte's atelier in Paris, and their works were similarly grounded in the "tradition" of modern art. In addition to the faceted forms and reconstructed space of Cézanne and the Cubists, they both sometimes utilized an independent line and a fuller color, more in the manner of the Fauves. Another artist of similar background was Barney Nestor, a younger man who had studied at the Académie Moderne in Paris with Fernand Léger and Amédée Ozenfant in the late twenties. On his return in 1927 he had been associated with Kenneth Callahan and several other artists and writers in what was briefly known as the Cherry Street Art Colony, a freewheeling establishment that provided a free pad and stimulating company for artistic friends until it disbanded under pressure from the landlord, who had received no rent for many months. Nestor's paintings, mostly portraits, were in a solid, somewhat somber, Cézannesque manner. These artists all handled paint in a delicate and relatively loose manner. Their work stood through the thirties as counterexamples against the excessively hard and linear treatments of popular artists like Grant Wood and Thomas Hart Benton, whose styles and subjects seemed marvelous to younger artists, but whose mannerisms were often perceived as even more exaggerated through the distortions of photographic reproduction. These artists, along with C. S. Price in Oregon and Emily Carr in British Columbia, were the area's first generation of serious artists, believing in art as an individual formulation of one's personal vision of reality. A few artists of slightly more conservative bent such as Eustace Ziegler, Jacob Elshin, and Ray Hill stood with them.

By 1930, Surrealism and Geometric Abstraction were dominant avant-garde tendencies in Europe. A number of the younger artists in the Northwest were attentive to the most recent developments, and their work involved adaptations and experimentations with these currents. Because they were young, their work was frequently eclectic and uneven, a groundwork for their later personal styles. But their alertness and sensitivity are often evident even in derivative work. Surrealism at the time was typified to most Americans by the works of Salvador Dali. Malcolm Roberts and William Gamble experimented with that meticulous descriptive manner to render desolate objects in a cold light and uncertain space. The objects Roberts cast into his eerie settings were less unexpected than those of Dali, and drew on the experience of deserted Pacific beaches and bleached driftwood. Morris Graves's surrealist tendency was more personal. Some of his loosely painted dark surfaces suggest dimly lit tidal flats, habited by strange outcroppings. Their titles—*Seasons, Burial of the New Law*—are evocative and ambiguous. After a wandering youth on the West Coast, in Texas, and around the Pacific, Graves began to settle into the Northwest in the mid-thirties. He worked for the WPA in 1936-37 and about that time began painting works in series, in which the animistic quality of natural forms and creatures seemed to anticipate his later better known paintings. Louis Bunce sometimes utilized a tipped and warped space, somewhat in the manner of Giorgio de Chirico, which he stocked with forms reminiscent of industrial decay, a kind of cluttered decrepitude that may have been an elliptical reference to the conditions of the time.

Mark Tobey's experiments with surrealist vocabularies, on the other hand,

incorporated fewer local references. He was in fact in England from 1931 to 1938, teaching at the progressive Dartington Hall School. His background already included study and work in both Chicago and New York and travels in Europe and the Near East. In the thirties he added Mexico and the Far East to his experience. The painter and ceramicist Bernard Leach accompanied him to China, and Tobey continued alone to Japan where he spent a month in a Zen monastery. Meshing curvilinear forms in some of Tobey's works through the decade suggest surging organic forces. These works are basically nonrepresentational, closer to the Surrealism of André Masson, involving automatic writing and other nonrational devices to evoke the unconscious. (Ambrose Patterson's most abstract experiments were also close to this kind of form.) During the mid-thirties Tobey began experimenting with the nervous and automatic-seeming "white writing" which later became identified with him (*San Francisco Street Scene* is an example). Certain works by other artists, which are clearly related to specific subjects, nevertheless also approach Surrealism in the eerie and unexpected quality of their effects. George Tsutakawa's looping, swirling simplification of barren land forms in a pale light is nearly surreal, for example, as is Rudolph Zallinger's densely and wittily detailed *Northwest Salmon Fishermen.*

All such works, and indeed many social realist works also, were considered "abstract" at the time because of their deliberate departure from strict visual accuracy toward stylization or distortion. Completely nonrepresentational or, as it was more likely to be called, nonobjective work was less common, but it had its adherents. Certain works in a surrealist vein approached total nonobjectivity, as mentioned above. Ruth Penington's prints constructed an image of crisp forms in a cubist-derived space; only the most elliptical allusions to objects were sometimes retained. The most thoroughly nonobjective artist in the area was Maude Kerns, whose paintings were very much in the vein of Vasily Kandinsky's hard-edge geometric abstractions. She had studied in Paris, Japan, and New York and was obviously familiar with the works of Kandinsky and Rudolph Bauer, often exhibited in New York at the Guggenheim Museum.

Artists of the New Social Realism

By far the largest number of artists in the Northwest in the thirties were, like their colleagues across the nation, involved with what may very broadly be called Social Realism. Very few of their works were intended to be visually realistic in a strict illusionistic sense. Neoclassic idealizations and expressionist distortions were explored widely and freely in the service of "Social Realism." The term implied, not visual literalness, but attention to the societal conditions that determined the tenor of human existence. Such attention often took the form of straight documentation of the hard, cold facts of the depression. But it also included virulent expressions of anger and revulsion at social conditions, and inspired formulations of solutions and ideals.

Photographers were perhaps the artists most obviously prepared to document such matters in a straightforward yet moving way. Minor White's extensive interpretation of the Portland scene, done for the WPA, exemplifies the technique of many of the era's finest photographers. Exhibiting sharp focus, clear piercing light, and strong compositional patterns, each photograph stands as a definitive insight into both the structure and the details of its subject. White's themes frequently concern the inner city with its decaying but dignified old buildings, or industrial scenes of docks, mills, factories, and train yards. Crisp, clean, and fully illuminated, but frequently unpopulated, these scenes sometimes carry a slightly melancholy air of unfulfilled potential. The photographs of Seattle's Dr. K. Koike include more views of landscape and countryside. Though he sometimes used sharply silhouetted forms or areas of concentrated light for dramatic effect, Koike more often employed a slightly softer focus and a more subdued or even muted light. His photographs seem understated and evocative.

Many of the painters already discussed, interested primarily in the formal aspects of art as a creative process, chose neutral subjects as the pretexts for their works—still lifes, nudes, figure groups, and quiet landscapes. In the paintings C. S. Price did in the thirties, loose full brushwork and planar structure (such as many

of the above artists experimented with) were adapted to themes of American history or local conditions. Price grew up on ranches in Wyoming, and his artistic education included little other than a year of schooling in St. Louis, an admiration for the Western illustrator Charles M. Russell, and exposure to recent European painting at the Panama and Pacific International Exposition in San Francisco in 1915. In spite of these limitations, Price's tenacious interest and stubborn experimentation led him far into cubist and expressionist developments by the thirties.

Most of the artists interested in the American scene or social realism chose, like Price, historical or contemporary subjects. But many of them inclined to somewhat more conservative styles than he. It seems permissible to approach these works through their thematic content rather than their visual styles, for the themes were important to the artists and their public, and certain themes, to judge by their pervasiveness, held great significance.

Current conditions were embodied very directly, for example, in the appearance of the cities. Kamekichi Tokita's paintings of Seattle's shabby advertising signs and weedy lots, of empty streets and alleys in a weak gray light, were unemotional looks at a society become decrepit even before the newness had worn off. Block prints of similar subjects, like those of Merdeces Hensley and Catherine Nicholson, were frequently more rhetorical and melodramatic interpretations of the raw urban environment. Their slashing diagonals and bold black areas were often of expressionist origin and conveyed some of the ferocity of their source. Seattle's shantytown, called Hooverville like many others, was depicted in a variety of manners: gloomily by Morris Graves, more wittily and ironically by Fay Chong and Irwin Caplan.

Several crucial themes were related to the condition of the cities and recurred nearly as often. One was the Worker (and his counterpart, the Mother). The block print by Prescott Chaplin, for example, is one of a series of half a dozen, each depicting a different trade or profession. Treatment of the Worker ranged from the documentary depictions of CCC workers, in series by Ernest Norling and Raymond Creekmore, to more highly stylized (and frequently by implication idealized) images such as Richard Correll's Paul Bunyan. The theme of the Mother was similarly varied, from Thomas Handforth's lithograph of a young Chinese mother with her baby to the powerful pyramid of David Lemon's sculpted *Mother and Children*.

The themes of the Worker and the Mother were related to the Noble Portrait —those frequent portraits in which a sturdy, powerful subject clearly impresses the viewer as a resilient and noble character. The directness of the gaze, the heaviness of the hands, and the largeness of the figure's form within the constricting frame are frequently clues to this enduring salt-of-the-earth nature. Earl Fields's *Study Hour,* Barney Nestor's portrait of the lead from *In Abraham's Bosom,* and Kenneth Callahan's portrait of Morris Graves are all of this type. Tobey's strange vision of a powerful woman's head may be related.

For some artists, enduring nobility was embodied most clearly in the most downtrodden members of society, and minority groups were very frequently depicted in this fashion, as in Nestor's and Handforth's works, just cited, for example. The rich, cultivated, or refined were almost never shown, in contrast to the portraiture of most other periods. Particularly to sculptors, it was apparent that the large pure forms of a Negro's head, or an Indian's, were stronger and more beautiful than the motley heads of Caucasians. George Blodgett's bronze head of José Rey Calavasa and Edna Guck's *Head of a Negro Boy* are typical. Dudley Pratt, when he taught at the University of Washington, preferred that his students sculpt from Negro models. There was extensive interest in work by or about minorities. Paintings by Jacob Lawrence and Anne Goldwaite, depicting the lives of urban and rural Negroes, respectively, were admired throughout the United States, and works by both of them were purchased in the Northwest.

Other themes related to the conditions of the times but treated with much more ambivalence concerned industry and the political process. The factory appears sometimes as a hopeful scene of potential activity, as in Minor White's photographs, Stella's *Factories at Night,* or Jacob Elshin's *Fisher Flour Mill*; but

equally often as a site shut down and deserted, as in Tobey's *Mill*. In either case, there is frequently present a sense of irony or ambivalence toward an institution whose absence spelled ruin but whose presence implied a degree of enslavement. The threat is fairly explicit in Vanessa Helder's looming *Factory Forms* (and in many of the WPA prints from outside the Northwest, or in Charlie Chaplin's film, *Modern Times*). It is implicit in Koike's photographs or in the illustration of "Tired Men Leaving the Steel Mill When the Shift Changes" from a book used in Seattle grade schools in the late thirties.

The political process was also a source of ambivalent feelings: simultaneously a desperate hope and an apparent failure. Don Freeman, a popular New York illustrator, depicted the frenzy and excitement of *Election Returns in Times Square* in a lithograph that was acquired by the Henry Gallery from the PWAP. But G. Bakker's PWAP print, *Around the Courthouse,* of an impenetrable façade looming over crumbling dwellings, is a far harsher view of the people's relation to their government. So is the comment implicit in David McCosh's loose expressionist rendering of an eagle's statue toppled amidst disarrayed benches in a weed-grown town square. Sometimes the relation of art to politics was even more direct; some artists' prints were sold to benefit the Communist Party. Many younger artists felt themselves identified with intellectuals and with the political left.

The rural ruin was the counterpart to the crumbling city. Vanessa Helder's desolate farmyard, ironically titled *Old MacDonald's Farm,* is similar in its focus to the many treatments of agricultural scenes so frequent in the Midwest at the time (for example, two lithographs acquired by the Seattle Art Museum in the thirties: John Steuart Curry's lithograph after his own well-known painting, *The Tornado,* and Charles Pollock's lithograph in the style of Thomas Hart Benton, teacher of both Charles and his brother Jackson Pollock).

The Northwest's image of itself was not identified with its farms, however, or with its fishing fleets, but with the lumber industry, and the Lumberman was one of the most important themes in the Northwest during the era. Kenneth Callahan's many easel paintings of loggers as large-limbed heroic figures in bleak light-shot environments make one want to have seen his immense mural of logging scenes. The mural, a sequence of 4-foot-wide panels totaling 12 feet high by 132 feet long, was painted independently of any commission, was never installed anywhere, and was eventually destroyed by fire. Callahan also did a smaller mural cycle of the merchant marine for the Marine Hospital in Seattle. (It has since been taken down, but one part of it has been remounted in the King County Administration Building, Seattle.) The Lumberman, as embodied in some of Callahan's works, seemed to be the prototypical Worker. He was idealized in the form of Paul Bunyan, as in the scenes by Richard Correll, who also did a mural of *Paul Bunyan at the Stillaguamish* for the high school at Arlington, Washington. Several sets of illustrations to the Paul Bunyan stories were done at the time, including a series by Lorna A. Livesley and another by D. J. McCormick (both now in the Seattle Public Library). But in this theme, too, the grim results emerge as well as the heroic efforts. The desecrated and ravaged look of logged-over land is evident in some of Callahan's works and in Ernest Norling's *Landscape,* for example. In works like these, the era's moralistic esthetics and social conscience came together in a conjunction of powerful but relatively conservative form and pointedly meaningful themes.

Escape Artists: Art for Easement and Entertainment

More daring and extravagant forms were invented to serve the wide range of arts with which the era sought to lighten the burden of life. In the design of relatively small objects (pottery, tiles, ash trays, and other items for household use) or relatively temporary items (fashionable clothing, window dressings, stage sets) artists experimented freely and even frivolously, and more permanent art, such as sculpture and architecture, was frequently affected by the taste manifested here. In general, the surge of dense, richly elaborated patterns of sharp geometric angles or of plump rosettes—which luxuriated during the twenties and were epitomized in many exhibits at the Exposition Internationale des Arts Décoratifs et Industriels

Modernes in Paris in 1925—receded in the thirties before a taste for the more spare and austere, culminating in the 1939 world fairs in New York and San Francisco. Instead of lush proliferations of decoration, the decade preferred the simple clarity of reiterated "speed lines," "neutral curves," or obvious radial or zigzag patterns. The richness of filigreelike metal work, whether in jewelry or in large-scale architectural ornament, became less common. Smooth expanses of hard-surfaced materials like tile, chrome, and white porcelain enamel became more common. A taste for the cold clear definition of silver (or chrome, or aluminum) over the warm ambiguous depths of yellow gold was consistent with this. Economic conditions undoubtedly encouraged this change in taste, since silver is cheaper than gold, and simple machine-tooled surfaces are both cheaper and easier to maintain than elaborately carved or cast ornaments.

Marcus Priteca's design for the Pantages Theater in Hollywood in 1929 was strongly influenced by his enthusiasm for the 1925 Paris exhibition. The foyers and lobbies as well as the great auditorium were spread with the dense staccato patterns of sculpture and geometric ornament. It carried to extremes, and at the same time regularized and domesticated, the sharp forms of earlier Futurists and Expressionists. Priteca might have gladly continued designing such grandiose movie palaces, but financial necessity reduced both the scale and the magnificence of theaters in the thirties, when assertive expanses of simple planes and contrasting areas of aggressive ornament were devised, as evident from photographs of Priteca's Centralia Theater of the mid-thirties for Centralia, Washington.

Economics was not the sole factor in such changes. Different ideals called for new forms. An admiration for strength and efficiency was embodied in the clear, simple shapes of streamlined objects or buildings, and even in their expanses of pure undecorated surface. A yearning for stability and security seemed to dictate blocky neoclassic forms for the underlying masses of a building (or sculpture, or object). Where the demanding taste for rigorous simplicity broke down before a desire for ornament, as in the Centralia Theater, that ornament verged on harshness in its strong, reiterated forms. These qualities of pattern, surface, and mass can be discovered in works of the widest imaginable range from the era, no matter what the function, scale, or resulting quality. A streamlined radio cabinet shares qualities of surface and form with an art museum; a clock encased in blue and cream plastic appears to emulate the dynamic energy of an airplane; the sharp, angular patterning of Indian pottery appeals to the same taste that admires the printed patterns of a factory-made scarf. Hand-crafted objects and mass-produced appliances partook of the same qualities.

Carl Gould's design for the Seattle Art Museum is a particularly suave example on a large scale of the era's taste for visual purity and strength. The emphatic massing at the façade's center contrasts strongly with the austere expanses of flat planes on either side. The aluminum grillwork at the entrance and the ornamentation of the interior are restrained additions in the same relatively austere manner, which soften any potential harshness without destroying the streamlined flow of the basic forms. With a traditional education at Harvard and the École des Beaux Arts in Paris, Carl Gould produced a design entirely in the modern taste but without the excesses of the decade's wilder experiments.

A different variant of the style was embodied in some of the theater sets designed by John Ashby Conway for productions at the University of Washington. More fantasy, whimsy, and exoticism could be incorporated into these temporary constructions than into architecture, but the love for strong effects, simple abrupt forms, and emphasis through reiteration persists, often abetted by sharp contrast achieved with the lighting.

In sculpture some of these tendencies found perhaps their purest expressions, but also complications and enrichment. The languid, frail, and subtly voluptuous versions of the female neoclassic figure type which had been common in the twenties were often replaced by a bulkier, more solid (frequently male) figure type, which was equally but differently neoclassic. Delicate contour line was often subordinated in the thirties to a sense of mass and modeling. The interior surfaces of figures had previously been relatively free of a role in the figure's definition and

could be independently elaborated, as in Art Nouveau, which directly preceded this. Now these surfaces became simple and uncomplicated expanses crucial to the definition of the figure's bulk. Relatively little large-scale sculpture was done in the Northwest at this time. Economic conditions undoubtedly had much to do with the absence of commissions for such work and the lack of artists in a position to undertake the expense themselves. But much of the small-scale sculpture executed has a quality of largeness or "monumentality" that would suffice for a much bigger work. The simplification of surfaces and the structuring by means of relatively few major masses contributed to this effect. The stylized works by David Lemon and Viola Patterson and the static massive forms by George Blodgett, Edna Guck, and George Tsutakawa all exemplify these qualities, as does the sculpture of John Flannagan acquired in the area during this period.

On the other hand, the very emphatic treatment of a sculpture's surface, either through extraordinarily refined polish or through elaborate patterning, sometimes resulted in a strength of surface qualities that distracted from the sense of mass. A peculiar tension sometimes resulted, for better or worse. George Blodgett's highly polished head of José Rey Calavasa has a share of this tension; and the *Salome* of Boris Lovet-Lorski, acquired by the Seattle Art Museum in the thirties, has a languid surface patterning more typical of the twenties. Certain other sculpture, in the taste for speed and efficiency—power in motion rather than power in reserve —suppressed both mass and surface refinement in favor of line. Examples are the arching, tapered forms of Dudley Pratt's *Seagull* or *Air Spirit* and, from outside the Northwest, Hunt Diederich's *Greyhounds Playing* or *Horses*. Another example is the taut and elegantly elongated *Bride* of Archipenko, done about the time he was a visiting teacher at the University of Washington in Seattle.

A lightness of spirit and an aspiration or hope seem to underlie these and many of the decorative forms of the thirties. Styles so mannered and witty that they verge on caricature or cartoon (as in Chong's or Caplan's lively views of Hooverville) embody this same cheerful and ironic mood in two dimensions. The art of the thirties never lost entirely a degree of humor and a suave sophistication that may have been its legacy from the twenties. But the wit and finesse of the thirties seemed more hardened, purified, and pointed. Compared to the more frivolous extravagances of the earlier jazz age, even the most playful forms of the depression years reveal a kinship with the solid styles and searching themes developed contemporaneously.

One major form of the visual arts that cannot be adequately represented in a static form is the movies. Like some of the clothes and household articles which capture so well the style of the era, movies were not made in the Northwest but nevertheless were an important and ever present part of life there. Recalling the movies, one sees again the apparent split that seemed to run through all art of the time—between flamboyant, wildly escapist inventions, on one hand, and grimly factual documentation, on the other. Walt Disney's increasingly elaborate fantasies, Busby Berkeley's extravaganzas, and the zany films of the Marx Brothers exemplify the wit and sophistication of art that set itself against the depression; while tough gangster films and documentaries like Pare Lorentz's *The River* and *The Plow That Broke the Plains* reflect the darker view. In retrospect, it is clear that the "realistic" documentaries and gangster films were at least as highly stylized as the obviously stylish concoctions. The intensity and the ponderous rhythms of the documentaries have analogues in the robust expressionist forms of the Social Realists, as the surreal dance sequences of the musicals find parallels in fashionable knickknacks and ornamental excesses.

As the thirties drew to a close, tensions mounted before the approaching war. Soon the war itself brought a decisive end to the aura of the decade. The economic hardships of the depression evaporated before new crises. In the Northwest, wartime industries and port activities brought another boom and a burst of growth comparable to that at the turn of the century. In art, creative experiment ground nearly to a halt; earlier visual modes and indeed the government art programs themselves were adapted to meet new necessities for propaganda and education in wartime. When the war ended, it was a new era. As art in the Northwest resumed its activity and growth, the names and interests had changed

to some degree, and through a few artists the concept of a "Northwest School" of painting achieved widespread recognition and impact elsewhere. But the groundwork had been laid and the precedents set in the thirties for these postwar developments by the artists and works brought into the area, by those exported from it, and by the increasingly great variety of artists and institutions within the Northwest itself.

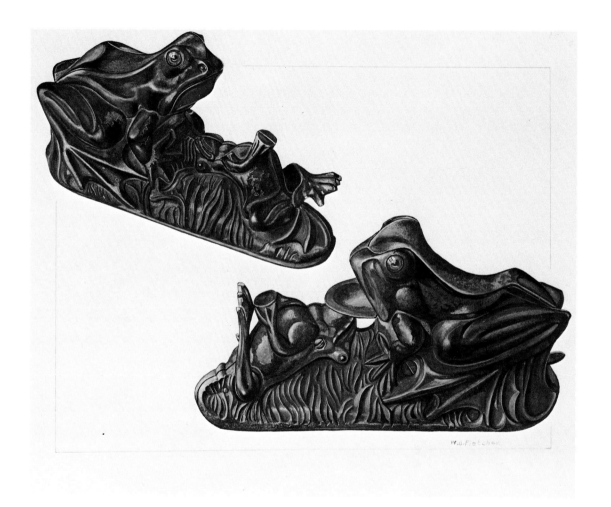

(50) William O. Fletcher. *Frog-shaped Coin Bank*

Dimensions are in inches; height precedes width.

The following abbreviations are used:

MHI	Museum of History and Industry, Seattle
NGA	National Gallery of Art
PAM	Portland Art Museum
SAM	Seattle Art Museum
SAM, Fuller Coll.	Seattle Art Museum, Eugene Fuller Memorial Collection
SPL	Seattle Public Library
UWHG	University of Washington, Henry Gallery
UWL	University of Washington Libraries
UWSA	University of Washington, School of Art

Paintings

1. **Guy Irving Anderson** (b. 1906)
 Still Life, ca. 1935
 Oil, 33½ x 31½. SAM, Gift of West
 Seattle Art Club, Katherine B. Baker Memorial
 Purchase Award

2. **Louis Bunce** (b. 1907)
 Structure No. 10, before 1942
 Oil, 36 x 28. PAM

3. **Kenneth Callahan** (b. 1906)
 The Feller, 1934
 Oil, 31⅛ x 22. SAM, Fuller Coll.

4. **Kenneth Callahan**
 Logging Road Construction, 1937
 Oil, 34½ x 44½. SAM, Fuller Coll.

5. **Kenneth Callahan**
 Portrait of Morris Graves, 1936
 Oil, 27¾ x 29½. UWHG

6. **Margaret Camfferman** (1881-1964)
 View from the Old Homestead Ranch, ca. 1931
 Oil, 25¼ x 29¼. SAM, Fuller Coll.

7. **Peter Camfferman** (1890-1957)
 Three Women at a Table, ca. 1932
 Oil, 24 x 20. SAM, anon. gift

8. **Jacob Elshin** (b. 1892)
 Fisher Flour Mill, 1934
 Oil, 29 x 38. SAM, gift of Public Works
 of Art Project

9. **Earl Fields** (b. 1899)
 Study Hour, 1937
 Oil, 38¾ x 31½. SAM, Fuller Coll.

10. **William Gamble** (b. 1912)
 River of Night, 1935
 Oil, 23 x 29. Coll. of the artist

11. **Morris Graves** (b. 1910)
 Burial of the New Law, 1936
 Oil, 43 x 38. SAM, Fuller Coll.

12. **Morris Graves**
 The Seasons, 1938
 Oil on Canvas, 43½ x 30½. UWHG

13. **Charles Heany** (b. 1897)
 Hills, Eastern Oregon, 1939
 Tempera, 5½ x 10. PAM

14. **Raymond Hill** (b. 1891)
 Coast Road, 1940
 Oil, 24 x 30. SAM, Fuller Coll.

15. **Walter Isaacs** (1886-1964)
 Bathers, ca. 1935
 Oil, 28 x 32. UWSA

16. **Walter Isaacs**
Interior, 1938-39
Oil, 30 x 40. UWHG

17. **Walter Isaacs**
Rehearsal, ca. 1938
Oil, 15½ x 19. UWSA

18. **Maude Kerns** (1876-1965)
Composition No. 27, 1944
Oil, 36 x 24. SAM, Fuller Coll.

19. **Jacob Lawrence** (b. 1917)
Harlem Society, 1943
Gouache, 22¼ x 30⅛. PAM

20. **David McCosh** (b. 1903)
Iron Bridge, before 1941
Oil, 20 x 30⅛. PAM

21. **David McCosh**
Landscape, before 1936
Oil, 19¾ x 23⅜. SAM, gift of West Seattle
Art Club, Katherine B. Baker Memorial Purchase
Award

22. **Carl Morris** (b. 1911)
Industrial Village, ca. 1939
Oil, 20 x 30¾. SAM, Fuller Coll.

23. **Carl Morris**
Mind Cellar, 1939
Oil, 24 x 36. PAM

24. **Barney Nestor** (b. 1903)
In Abraham's Bosom
Oil, 41 x 23. Coll. of Miss Helen Blackwood

25. **Patricia K. Nicholson** (b. 1900)
Joachim and St. Anne
Egg tempera, 22½ x 18¼. Coll. of the artist

26. **Kenjiro Nomura** (1876-1956)
Street, 1932
Oil, 23½ x 28⅝. SAM, gift of West Seattle
Art Club, Katherine B. Baker Memorial
Purchase Award

27. **Ernest Norling** (b. 1892)
Logged Off Land, 1931
Oil, 35½ x 27½. SAM, Fuller Coll.

28. **Amédée Ozenfant** (1886-1966)
La Belle Vie
Oil, 28 x 20. Coll. of Mrs. Viola Patterson

29. **Ambrose Patterson** (1877-1967)
Irises, 1931
Oil, 21½ x 32. UWHG

30. **Ambrose Patterson**
Place du Palais Royal, 1930
Oil, 20 x 24. Coll. of Mrs. Viola Patterson

31. **Ambrose Patterson**
Mexican Women, 1935
Fresco, 15 x 10. Coll. of Mrs. Viola Patterson

32. **Viola Patterson** (b. 1898)
Two Mexican Women, 1934
Oil, 25 x 20. Coll. of the artist

33. **C. S. Price** (1874-1950)
The Mail Coach, ca. 1936
Oil, 38 x 44. PAM

34. **Malcolm Roberts** (b. ca. 1917)
Drift No. 2, 1936
Tempera, 20⅝ x 25⅝. SAM, Fuller Coll.

35. **Mark Rothko** (signed M. Rothkowitz)
(1903-70)
Beach Scene, ca. 1929
Oil, 14¼ x 15½. Reed College

36. **Joseph Stella** (1880-1946)
Factories at Night, before 1936
Oil, 36 x 36. PAM

37. **Mark Tobey** (b. 1890)
Head of a Woman, 1933
Oil, 18½ x 14½. UWHG

38. **Mark Tobey**
Moving Forms, 1930
Gouache, 10¾ x 19½. SAM, Fuller Coll.

39. **Kamekichi Tokita** (1897-1948)
Billboards, before 1933
Oil, 19 x 23. SAM, gift of Mr. Kamekichi Tokita

40. **Kamekichi Tokita**
Drugstore, 1933
Oil, 16⅝ x 20½. SAM, gift of Mr. Kamekichi
Tokita

41. **George Tsutakawa** (b. 1910)
Terrestrial Rhythm, 1940
Oil, 34 x 43. Coll. of the artist

42. **George Tsutakawa**
Study for a mural, 1934
Oil, 22 x 14. Coll. of the artist

43. **Rudolph Zallinger** (b. 1919)
Northwest Salmon Fishermen, 1941
Tempera, 25¾ x 35⅝. SAM, Fuller Coll.

Drawings and Watercolors

44. **Alf Bruseth** (b. 1899)
Humpty Dumpty Coin Bank
Gouache, 13 x 10½. NGA, Index of American
Design

45. **Irwin Caplan** (b. 1919)
Hooverville, 1937-38
Watercolor, 15 x 20. Coll. of the artist

46. **Irwin Caplan**
Mexican Theme, 1937
Ink, 14½ x 20. Coll. of the artist

47. **Doriece Colle**
Costume for the Miller's Wife in "The Three-cornered Hat" (two studies and a photograph), 1935
Watercolor and photography, 15 x 20. Coll. of John Ashby Conway

48. **William Cumming** (b. 1917)
Worker Resting, 1941
Gouache, 14½ x 19⅜. SAM, Fuller Coll.

49. **Walt Disney** (1901-66)
Illustration from *Pinocchio,* 1939
Tempera on celluloid and paper, 10⅝ x 17. SAM, Fuller Coll.

50. **William O. Fletcher** (b. 1884)
Frog-shaped Coin Bank
Gouache, 11¼ x 13¾. NGA, Index of American Design

51. **Raymond Jonson** (b. 1891)
Watercolor No. 5, 1938
Watercolor and air brush, 30 x 21⅛. PAM

52. **Ernest Norling** (b. 1892)
The Telephone Line—Setting Poles (C.C.C. camp series), 1934
Pencil drawing, 15 x 20. SPL

53. **Walter Shelly Phillips** ("El Comancho") (1867-1940)
Title page of *American Indian Primer*
Watercolor, 15 x 12. UWL, Special Collections Division

54. **Walter Shelly Phillips** ("El Comancho")
Ancient Pottery, page 2 of *American Indian Primer*
Watercolor, 15 x 12. UWL, Special Collections Division

55. **Mark Tobey** (b. 1890)
Male Harlequin, 1933
Watercolor, 9¾ x 7½. SAM, Fuller Coll.

56. **Mark Tobey**
Mill, 1935
Watercolor, 18 x 24. UWHG

57. **Mark Tobey**
San Francisco Street, 1934
Watercolor and gouache, 15 x 11. UWHG

58. **Eustace Ziegler** (1881-1969)
Squaw and Dog, 1934
Watercolor, 24 x 19. SPL

Prints

59. **G. Bakker**
Around the Courthouse, 1934
Blockprint, 12 x 9¾. UWHG, Public Works of Art Project

60. **Julia Caskey** (b. 1909)
The Lost Chord, 1940
Blockprint, 6½ x 5½. UWHG

61. **Prescott Chaplin** (b. 1897)
Los Curas
Blockprint, 5 x 7. UWHG

62. **Fay Chong** (b. 1912)
Haircut (Hooverville)
Woodcut, 18 x 24. SPL

63. **Richard Correll** (b. 1904)
Plowing (Paul Bunyan Series), 1941
Lithograph, 9¾ x 13⅛. UWHG

64. **Raymond Creekmore** (b. 1905)
C.C.C. Woodcutters, ca. 1934
Lithograph, 9 x15½. UWHG, Public Works of Art Project

65. **John Steuart Curry** (1897-1946)
Tornado, 1932
Lithograph, 10 x 14⅛. SAM, gift of Northwest Printmakers

66. **Don Freeman** (b. 1908)
Election Returns, ca. 1933
Lithograph, 11 x 14. UWHG, Public Works of Art Project

67. **William Givler** (b. 1908)
Road's End, before 1943
Lithograph, 11¼ x 16½. SAM, Fuller Coll.

68. **Harry Gottlieb** (New York)
Rock Drillers, before 1943
Silkscreen print, 13½ x 13¼. PAM

69. **Thomas Handforth** (1897-1948)
Motherhood, 1934
Lithograph, 10 x 12¾. SAM, gift of Northwest Printmakers

70. **Charles Heany** (b. 1897)
The Audience, 1931
Blockprint, 5⅛ x 7. UWHG

71. **Z. Vanessa Helder** (b. 1909)
Factory Forms, ca. 1940
Lithograph, 9⅞ x 14⅛. PAM

72. **Z. Vanessa Helder**
Old MacDonald's Farm, 1941
Lithograph, 9½ x 13. SAM, gift of Northwest Printmakers

73. **Merdeces Hensley** (b. 1893)
Backyard, Denny Hill
Blockprint, 11⅝ x 8. UWHG

74. **Robert Bruce Inverarity** (b. 1909)
Indians Gathering Bark, before 1944
Blockprint, 13 x 11. SPL

75. **Paul Landacre** (1893-1963)
August 7, 1937
Wood engraving, 12⅛ x 8. SAM, gift of
Northwest Printmakers

76. **Catherine Nicholson**
Old and New Seattle
Blockprint, 11⅝ x 8. UWHG

77. **Ruth Penington** (b. 1905)
Composition, 1929
Blockprint, 6 x 6. Coll. of the artist

78. **Ruth Penington**
No. 1, 1936
Blockprint, 4 x 3¾. Coll. of the artist

79. **Ruth Penington**
Sodom and Gomorrah, ca. 1935
Book with woodcut text and illustrations, 11½ x
9½. Coll. of the artist

80. **Ralph Austin (Tony) Perez**
Negro Revolt, ca. 1937
Blockprint, 6 x 8. Coll. of Mrs. Paul Ashford

81. **Charles Pollock** (b. 1902)
Look Down That Road, 1935
Lithograph, 9 x 12. SAM, gift of Northwest
Printmakers

82. **Lloyd Reynolds** (b. 1902)
Knowing the Places, 1938
Wood engraving, 7¼ x 5¼. SAM, gift of
Northwest Printmakers

83. **Lloyd Reynolds**
Legendary Figure, ca. 1938
Wood engraving, 6 x 4. PAM

84. **Helen Rhodes** (1875-1938)
Composition: Window View, ca. 1930
Lithograph, 10 x 7. Coll. of Ruth Penington

85. **Charles Surendorf** (b. 1906)
Five and Ten, 1938
Wood engraving, 8½ x 11⅞. SAM, gift of
Northwest Printmakers

86. **Diane Thorne** (b. 1895)
Breakers
Etching, 9 x 9⅞. UWHG

87. **George Tsutakawa** (b. 1910)
Shipping, 1931
Blockprint, 5¾ x 6¾. UWHG

88. **Julius Twohy** (Washington State)
Speed Color and Action, ca. 1938
Lithograph, 16 x 9⅜. UWHG

89. **Julius Twohy**
Tom Tom and Drums, ca. 1938
Lithograph 14⅛ x 17. UWHG

90. **Lucia Wiley** (b. 1906)
Saturday Night, 1935
Color woodcut, 7 x 7¾. SAM, gift of Northwest
Printmakers

91. **Frances Wismer** (b. 1906)
Gymkhana, 1936
Block print (black and brown on tan paper),
10 x 7⅜. UWHG

Photographs

92. **Imogen Cunningham** (b. 1883)
Portrait of Mme Ozenfant, ca. 1936
Photograph, 9⅓ x 7⅓. Coll. of Mrs. Viola
Patterson

93 through 111.
Dr. Kyo Koike (1878-1947)
Nineteen photographs, early thirties. UWL,
Special Collections Division
(titles are descriptive only)

 93. Distant mountain valley, 7 x 10
 94. Tree before low hills, 10 x 7
 95. Barren misty valley, 7 x 10
 96. Dead crags above distant mists, 10 x 7
 97. Plowing, 8 x 12
 98. Meadow and old trees, 8 x 12
 99. Poplar tree and barn, 11¼ x 4
 100. Boat at anchor, 12 x 7
 101. Rowboat with Japanese parasol, 9 x 6
 102. Industrial valley, 9 x 13
 103. Sawdust burner under snow, 10 x 8
 104. Roof and three smokestacks, 10 x 7
 105. Snow over harbor, 7½ x 11
 106. Distant sawmill, 10½ x 7½
 107. Marine Hospital, Seattle, 9 x 7
 108. Northern Life Tower, Seattle, 9 x 7
 109. Four planes, cumulus clouds, 9 x 12
 110. Man in alley, 13 x 10
 111. Girl reading on library steps, 11 x 8

112 through 135.
Minor White (b. 1908)
Twenty-four photographs, subjects mainly in the
Portland area, 1938-39. PAM, from the Work
Projects Administration
(titles are descriptive only)

 112. View out a café window, 12¾ x 10½
 113. Railroad station, 10¼ x 13¼
 114. Freight car, 17 x 10½
 115. Tractor parts, 13⅜ x 10⅜
 116. Granary, 10½ x 13
 117. Port, 13¼ x 10½

118. Boats, 13¼ x 10½
119. Waterpipes, factory, and port, 12¾ x 10
120. Lumber yard and dock, 10½ x 13½
121. Houses, Hall Street, 10½ x 13½
122. Boat in mist, 13¼ x 10⅝
123. Water tower and factory, 13¼ x 10⅜
124. Crane, 13½ x 10⅝
125. Old buildings and people, 13¼ x 10⅜
126. Old buildings under bridge, 13½ x 10½
127. Brick side of old buildings, 13½ x 10½
128. Store front, 10⅛ x 13⅜
129. Hand laundry, 13½ x 10⅝
130. Grain elevator and bridge, 10 x 13⅜
131. Log booms on river, 13¼ x 10¼
132. Grandma, 13 x 10¼
133. Sailor with two girls, 9⅜ x 7
134. Catherine Creek, eastern Oregon, 7⅜ x 9½
135. High Valley Farm, 7½ x 9¼

Drawings, Watercolors, and Photographs Related to Architecture and Settings

136. Bridal display, store window
Photograph by Frank A. Kunishige (1878-1960),
8 x 10. UWL, Special Collections Division

137. Bridal display, store window
Photograph by Frank A. Kunishige, 8 x 10.
UWL, Special Collections Division

138 through 140.
Theater productions at the University of
Washington

138. Chekhov's *The Wedding*
139. Wilde's *Importance of Being Earnest* (1935)
140. Riley's *Personal Appearance*, Betty Kennedy
as Carole Arden (1937)
Three photographs by Charles Bell, each 8½ x 11.
Coll. of John Ashby Conway

141. **John Ashby Conway** (b. 1905)
Set for *The Three-cornered Hat* (University of
Washington, 1935)
Photograph by Charles Bell, 8½ x 11. Coll. of
the artist

142. **John Ashby Conway**
The Penthouse Theater (University of
Washington) set up for *Accent on Youth* (1936)
Photograph by Charles Bell with watercolor study
on mat, 14 x 10½. Coll. of the artist

143 and 144.
John Ashby Conway and George McKay
Epoch—An American Dance Symphony
(University of Washington, 1936)

143. The chorus before industrial smokestacks
144. The chorus turned to machines
Photographs by Charles Bell, 8½ x 11. Coll.
of John Ashby Conway

145 through 170.
Carl Gould (1874-1939)
of Bebb and Gould, Architects, with assistants
Drawings and sketches for the Seattle Art
Institute (now the Seattle Art Museum), 1932-33.
Coll. of Carl Gould, Jr.

Pencil on tissue except where noted.
145. Plan of museum and grounds printed on
linen, 18 x 24
146. Front elevation as approved, 12 x 24
147. Back elevation as approved, 12 x 24
Sketches of front elevations:
148. Greek, with pools, 12 x 24
149. Neo-Classic, 12 x 24
150. Neo-Classic with pools, 12 x 24
151. Egyptian, 12 x 24
152. Similar to final, 12 x 24
153. Similar to final, 12 x 24
Sketches of interiors:
154. Court (with classical sculpture), 12 x 24
155. Court (with Michelangelo sculpture),
12 x 18
156. Oriental and Jade room, 13 x 18
157. Jade display cases, 13 x 18
Lobby:
158. Full view, entrance wall, "Sales—Telephone,"
14 x 24
159. Full view, entrance wall, squared wall,
12 x 24
160. Full view, entrance wall, sculpture, 12 x 24
161. View into north gallery, 16 x 24
162. View into south gallery, 12 x 16
Details:
163. Entry, 12 x 12
164. Main entrance, elevation, 24 x 30
165. Gate to garden court, 15 x 16
166. Exterior fountain, north end of façade,
16 x 22
167. Exterior fountain, active, 16 x 22
168. Exterior grill, to scale, "drawing 108," 24 x 12
169. Exterior grill, to scale, "drawing 109," 24 x 12
170. Exterior grill, to scale, "drawing 110," 24 x 12

171 through 180.
B. Marcus Priteca (1891-1971) with assistants
Drawings and sketches for The Pantages Theater,
Hollywood, Calif., 1929. Estate of B. Marcus Priteca

171. Longitudinal section, wall of auditorium, pen-
cil, 20 x 28
172. Doily on auditorium ceiling, charcoal, 20 x 28
173. Sculpture on an inside wall, pencil, 20 x 28
174. Panoramic perspective of auditorium, pencil,
40 x 28
175. Selected interior studies, pencil and crayon, 20 x 28
176. Longitudinal section, whole theater, ink, 36 x 60
177. Main arch of lobby, pencil, 36 x 60
178. Lobby, with sculpture, pencil, 36 x 60
179. Sections of lobby, detailing, pencil, 36 x 60
180. Ceiling construction over auditorium, pencil,
36 x 60

181. **B. Marcus Priteca**
Night perspective of Pantages Theater, Hollywood, 1929
Charcoal, ink, and color, 24 x 30. Estate of B. Marcus Priteca

182. **B. Marcus Priteca**
Pantages Theater (Hollywood), 1929
Photograph of auditorium, 15 x 18. Estate of B. Marcus Priteca

183 through 185.
B. Marcus Priteca
Pantages Theater (Hollywood), 1929
Three photographs of lobby stairs and sculpture, 8 x 10. Estate of B. Marcus Priteca

186 through 193.
B. Marcus Priteca
Centralia Theater (Centralia, Wash.)
Eight photographs: box office, lobbies and powder rooms, and auditorium including wall decorations, 8 x 10. Estate of B. Marcus Priteca

Sculpture

194. **Alexander Archipenko** (1887-1964)
The Bride, 1936
Terracotta, 34 x 6 x 4. SAM, Fuller Coll.

195. **George Blodgett** (b. 1888)
José Rey Calavasa, 1935
Bronze, 6½ x 5¼ x 5. SAM, Fuller Coll.

196. **José de Creeft** (b. 1884)
Cactus, before 1940
Stone, 21 x 17. SAM, Fuller Coll.

197. **José de Creeft**
Mallorcan Girl, before 1936
French stone, 13 x 8 x 7. SAM, Fuller Coll.

198. **Hunt Diederich** (1884-1953)
Greyhounds Playing, ca. 1933
Bronze, 21½ x 36 x 10. SAM, gift of Mrs. John C. Atwood, Philadelphia, Pa.

199. **Hunt Diederich**
Playing Horses
Bronze, 18 x 17. SAM, gift of Mrs. John C. Atwood, Philadelphia, Pa.

200. **John Flannagan** (1898-1942)
Tired Ass, 1930
Granite, 9¾ x 13. PAM

201. **William Gamble** (b. 1912)
Abstract Sculpture, 1934
Soapstone, 19 x 11 x 5. Coll. of the artist

202. **Edna Guck** (b. 1904)
Head of a Negro Boy, 1935
Sandstone, 4¼ x 5 x 4. SAM, gift of the New York Public Works of Art Project

203. **David Lemon** (b. 1908)
Mother and Children, 1938
Terracotta, 17½ x 13 x 15. SAM, Fuller Coll.

204. **Boris Lovet-Lorski** (1891–1962)
Salome, ca. 1933
Bronze, 15½ x 28½ x 10. SAM, gift of Mrs. John C. Atwood, Philadelphia, Pa.

205. **Viola Patterson** (b. 1898)
Kneeling Female Borne on Clouds, 1936–37
Terracotta, 18. Coll. of the artist

206. **Viola Patterson**
Female Torso, 1936–37
Terracotta, 16. Coll. of the artist

207. **Viola Patterson**
Woman on a Horse, ca. 1935
Terracotta, 10. Coll. of the artist

208. **Dudley Pratt** (b. 1897)
Air Spirit, 1932
Lead, 64 x 50. SAM, Fuller Coll.

209. **Dudley Pratt**
Group, 1936
Marble, 18 x 12 x 3. SAM, Fuller Coll.

210. **Dudley Pratt**
Seagull, 1928
Lead, 13¼ x 10. SAM, Fuller Coll.

211. **George Tsutakawa** (b. 1910)
Abstract Sculpture, 1934
Soapstone, 16 x 5½ x 4½. Coll. of the artist

212. **George Tsutakawa**
Figure Lying beneath Hills and Sky, 1934
Terracotta relief, 5½ x 12¾. Coll. of the artist

213. **George Tsutakawa**
Northwest Fisherman (Self-Portrait), 1934
Soapstone, 14 x 6 x 5. Coll. of the artist

214. **Eugenie Worman** (d. 1944)
Nude Woman, ca. 1935
Terracotta, 12. Coll. of Ruth Penington

Miscellaneous

(Designers or artists unknown, with the few exceptions noted. Works are grouped by material or use: souvenirs, household objects, pottery, clothing and jewelry.)

215. Four souvenir postcards, Chicago World's Fair, 1933
Color lithograph cards, 3½ x 5½. Private coll.

216. Souvenir plate, Golden Gate International Exposition, 1939
10 diameter. Coll. of Mr. Howard Kottler

217. Souvenir spoon, Golden Gate International Exposition, 1939
6 length. Coll. of Mr. Howard Kottler

218. Souvenir plate, New York World's Fair, 1940
10 diameter. Coll. of Mr. Howard Kottler

219. Eight souvenir postcards, New York World's Fair, 1939
Color lithograph cards, 3½ x 5½. Coll. of Miss Ronda Skubi

220. Architectural panels, painted metal, Richfield Building, Los Angeles
84 x 19. Coll. of Mr. and Mrs. Vernon Koenig

221. Medal: "Faculty Medal. University of Washington."
Bronze, 3⅞ x ⅓. UWSA

222. Medal: "Focus," awarded to Dr. Kyo Koike
Bronze, 1¾ x 1. UWL, Special Collections Division

223. Medal: "Iris," awarded to Dr. Kyo Koike, 1936–37
Bronze, 2 x 1½. UWL, Special Collections Division

224. Medal: "Klank en Beeld 1932," awarded to Dr. Kyo Koike
Bronze, 1½ x 1. UWL, Special Collections Division

225. Medal: "TATATÓVÁROS," awarded to Dr. Kyo Koike, 1938
Bronze, 2 diameter. UWL, Special Collections Division

226. Ashtray, blue glass, triangular shape
1½ high x 4½ sides. Private coll.

227. Cigarette box and ashtray, blue glass with chrome lids and chrome tray, octagonal black plastic handle on lid, radial patterns on glass bottoms
2¼ high x 7⅔ x 4½. Private coll.

228. Cigarette case, chrome and black enameled metal
2¾ x 3¾ x ⅔. UWSA

229. Coasters, ceramic, glazed yellow or green, with flower pattern under glaze
3 diameter. Private coll.

230. Box, chrome-plated metal lined with wood, concentric circles and leaping hounds on lid, geometric patterns on sides, Japanese origin, ca. 1935-40
1⅔ x 3¾ x 3¼. Private coll.

231. Lidded box, off-white high-glaze crackle surface, striated corners and cat on lid, late thirties
5½ x 4 x 3½. Private coll.

232. Pair of photograph mounts, silver-painted metal bases with step shaping, supporting double glass for photograph (one round, one rectangular)
3 x 2¾ and 4 x 3½. Private coll.

233. Picture frame, glass painted black and gold, metal corner clips
5 x 4. Coll. of Miss Ronda Skubi

234. Picture frame, double glass, striated
14 x 12. Coll. of Mr. and Mrs. Spencer Moseley

235. Telechron electric clock, cream face with brown numerals, edged in brass, mounted in blue lucite on cream plastic base, late thirties
7 x 6. Private coll.

236. Candle holder, pink frosted glass, ca. 1930
2½ x 4 x 4. Private coll.

237. Statuette of woman dancer, plaster painted cream, late thirties
8½ x 6¾ x 2¼. Private coll.

238. Light fixture, hexagonal frosted pink glass patterned in rosettes and step patterns, ca. 1930
11 x 9½ diameter. Private coll.

239. Light fixture, white glass globe, octagonal stepped shape
15½ x 9. Coll. of Mr. Howard Kottler

240. Ceramic tile, high-glaze, yellows, white, blue, and greens
6 x 6 x ⅔. Coll. of Mr. Howard Kottler

241. **George Tsutakawa** (b. 1910)
Ceramic tile decorated with figure playing stringed instrument, in black, tans, greens, and blue glazes, ca. 1933
7½ x 5¾ x 1. Coll. of the artist

242. Perfume atomizer, clear lucite tube set in four horizontal lucite rectangles, blue at intersections
3½ x 2¼ x 1½. Private coll.

243. French perfume bottle, clear glass with raised design and brown paint
2¾ x 2 x ½. Coll. of Ms. Patricia Bauer

244. Vanity table jars, two small and one large, blue glass with chrome lids and blue plastic handles, mirrors mounted inside lids of smaller jars
Heights 5¾ and 3¼ total, 3½ diameters. Private coll.

245. Covered dish or powder box, gold-finished metal with black painted decoration
1½ height plus handle, 3½ diameter. UWSA

246. Vase, beige crackle-glaze pottery with painted peacocks of blue, lavender, green, yellow, and beige, early thirties
4 x 4¼. Private coll.

247. **Trenton Potteries**
Vase, high-glaze white pottery, rectangular, ca. 1935–40
7 x 4 x 2½. Coll. of Mr. and Mrs. Spiros Pavlou

248. "Pacific" pottery
Vase, white glazed pottery, rectangular
6½ x 3⅓ x 3⅓. Private coll.

249. Vase, plaster spray-painted with stencils in black, green, red, yellow, blue
7½ x 6½ diameter. Private coll.

250. Pitcher-shaped vase, mat white glazed pottery
5¼ x 4⅓ x 1¾. Private coll.

251. Pitcher, maroon pottery, late thirties
5⅓ x 5½ x 2¼. Coll. of Mr. and Mrs. René Bravmann

252. **Isabelle**
Black pottery plate with partial high glaze, Southwest American Indian, 1934
10 diameter. Coll. of Mrs. Viola Patterson

253. **Marie [Martinez] and Julian**
Plate, pottery with contrasting high and mat black glazes, Southwest American Indian from Ildefonso, N.M., ca. 1935
12 diameter. Coll. of Miss Ramona Solberg

254. Pot, black pottery with mat-glaze incised pattern on high-glaze surface, Southwest American Indian
7 x 8½. UWSA

255. Trivet, wood painted turquoise with metal overlay cut out in pattern of gazelle in forest, ca. 1935–40
½ x 7½ diameter. Private coll.

256. Salt and pepper shakers, green glass with brown plastic lids
3 x 1½. Private coll.

257. Salt shaker, black and pearl white, high-glazed ceramic, Japanese origin, ca. 1935
6½ x 2½. Coll. of Mr. and Mrs. Vernon Koenig

258. Cream and sugar set, white-glazed pottery
2⅓ height x 3⅓ base width x 1⅔ base depth. Coll. of Miss Susan Munch

259. Sugar bowl, glass painted cream, silver, and orange
4½ x 4 diameter. Coll. of Mr. and Mrs. Vernon Koenig

260. Berry set (creamer and sugar shaker); cream ceramic painted blue, orange, yellow, green, and black; Japanese origin
5¾ x 2¾ each. Private coll.

261. Crumber set, copper-handled brush and tray, ca. 1930
Brush 3½ x 4½, tray 7 x 5½. Private coll.

262. Teapot on saucer, white and blue striped high-glaze ceramic, Japanese origin
Teapot 3 x 3, saucer 3½ diameter. Coll. of Mr. and Mrs. Vernon Koenig

263. **George Tsutakawa (b. 1910)**
Bowl, wood painted on inner surface in oil, with man on road to hills, ca. 1932
1½ x 8 and 8½ diameters. Coll. of the artist

264. Covered dish and matching container, stainless steel with brass handles
Dish 3⅓ plus handle x 6⅓ diameter, container 3 x 2⅓. UWSA

265. Dish, white glaze with pink decoration, Japanese origin
1½ x 6¼. UWSA

266. Dish, blue glass set in silver-plated base and divided into three sections, Japanese origin
2 x 5. Coll. of Mr. and Mrs. Vernon Koenig

267. Booklet, *The Longest Gangplank in the World,* for the French Line, Paris and New York, 1930. Coll. of Mr. and Mrs. Vernon Koenig

268. **Edna McGuire**
A Full-grown Nation, Macmillan Co., 1937
History text used in Seattle schools. Private coll.

269. **Gabrielle (Coco) Chanel (1883–1971)**
Two-piece suit of navy wool knit, straight skirt and boxy jacket with lapels, red and white trim along sleeves and diagonally over jacket, ca. 1939. MHI

270. **Mme Louise Thiry (1878–1952)**
Evening dress, sleeveless, V-neck, no waist, diagonal hem; sheer white crepe with clusters of white beading over upper portions, hanging strands of beads over the skirt below diagonal hipline, ca. 1932. MHI

271. **Mme Louise Thiry**
Evening gown, long, sleeveless, V-neck, high waist; beige lace with upper skirt overlaid with four diagonal tiers of black lace ruffling. MHI

272. Bathing suit, two-piece, cotton printed in blues, orange, yellow, beige, and gray. Private coll.

273. Dress, sleeveless, waistless, round neck; pale lavender silk in tiny accordion pleats hanging from drawstring neck; fine silk cord with tiny striped beads spaced 1½ inches at neck and down sides. Given to Seattle gallery owner Zoe Dusanne about 1930 by New York abstract painter Charmion von Wiegand. MHI

274. Evening dress and jacket; jacket of white satin, collarless, long sleeves, fitted; dress of maroon satin with tiny white figure, sleeveless, V-neck with lapels, high waist, flared skirt, ca. 1933. MHI

275. Two-piece dinner suit, long skirt, semi-fitted jacket with padded shoulders; black crepe with black jet paillettes toward shoulder, hem of jacket, and hem of skirt, New York origin, ca. 1939. MHI

276. Scarf, rayon printed blue, navy, red, orange, and yellow
15 x 55. Private coll.

277. Bracelet, cream plastic, striated
3 diameter x ¾ wide. Coll. of Mr. and Mrs. Vernon Koenig

278. Bracelet, silverplate, four bands joined at ends
2½ x 2 x 1½ wide. Coll. of Mr. and Mrs. Vernon Koenig

279. Belt buckle, white and turquoise enamel pattern of four crossing belt buckles
2½ x 2½. Coll. of Mr. Howard Kottler

280. Belt hooks, plastic
1¼ x 1¼ and 1¾ x ¾. Private coll.

281. Brooch, orange-brown plastic
1 x 3¼. Private coll.

282. Six clip pins, five plastic, one rhinestone
1½ to 2 long. Private coll.

283. Pin, blue glass set in sterling silver, Mexican origin
2 x 1½. Private coll.

284. Black purse with black cord drawstring; vertical stripes, widening toward bottom, of pearly beads
6 x 6. MHI

285. Chain metal purse painted black, cream, yellow, and green; chain handle, zigzag fringed bottom, diagonal top; Mandalian Mfg. Co.
7½ x 3½. MHI

286. Envelope purse, shell pattern of black jet beads, ca. 1935
3 x 6. MHI

287. Evening bag, enameled chain mesh of cream and blue, chain handle
7 x 4½. Coll. of Ms. Patricia Bauer

288. Gold mesh evening bag, hangs as a pentagon from gold string handle, round top with rosette and compact mounted to underside, ca. 1930
6 x 4½. MHI

289. Gray kid leather bag, flat pentagonal shape, flap and bottom fringed with steel beads; tiny separate coin purse inside edged with same
4 high. MHI

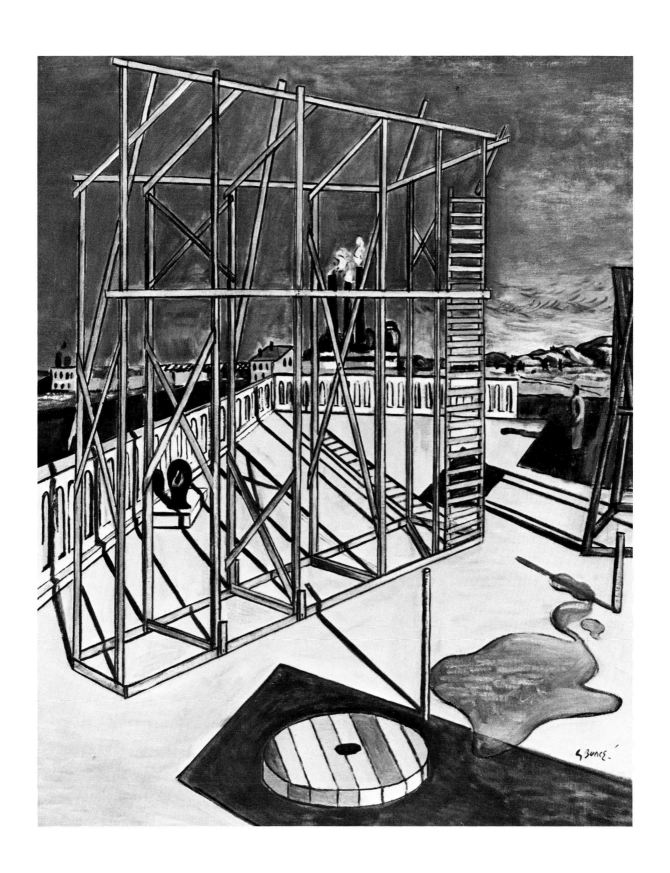

(2) Louis Bunce, *Structure No. 10*

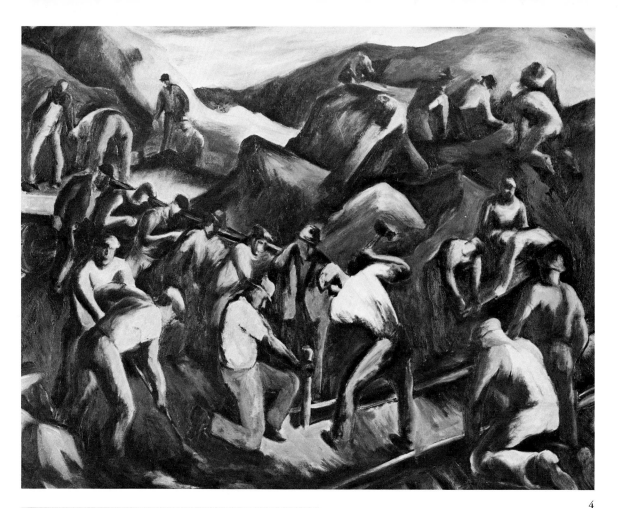

4

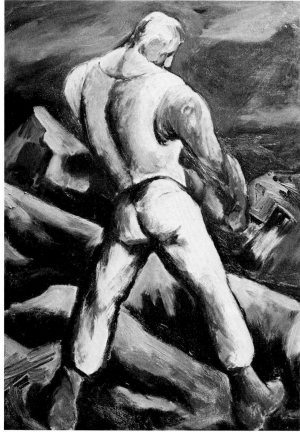

3

(3) Kenneth Callahan. *The Feller*
(4) Kenneth Callahan. *Logging Road Construction*

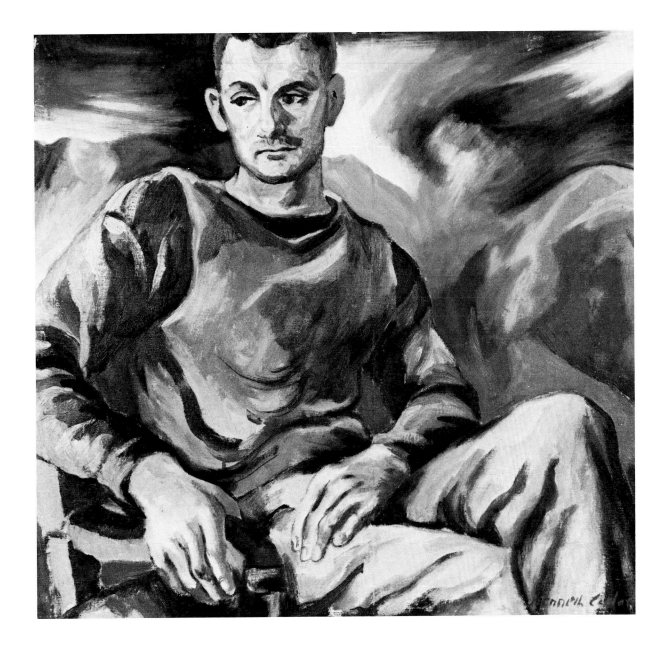

(5) Kenneth Callahan. *Portrait of Morris Graves*

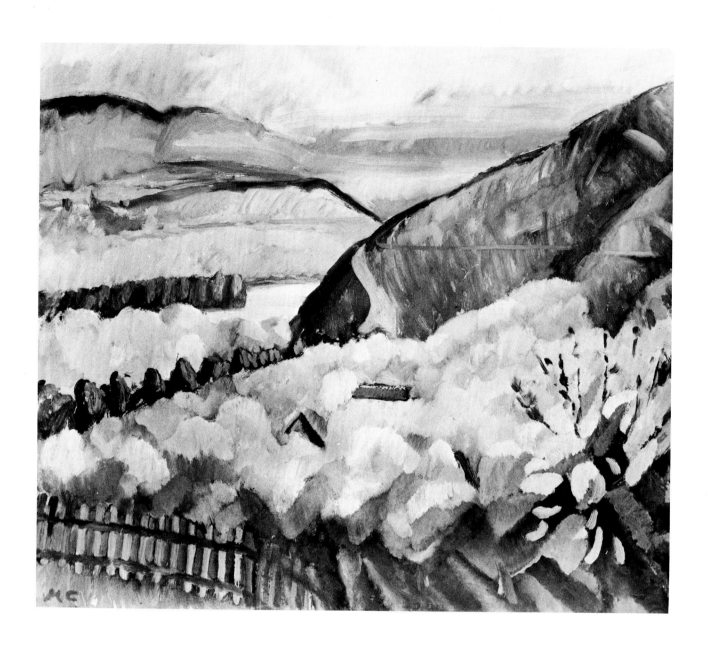

(6) Margaret Camfferman. *View from the Old Homestead Ranch*

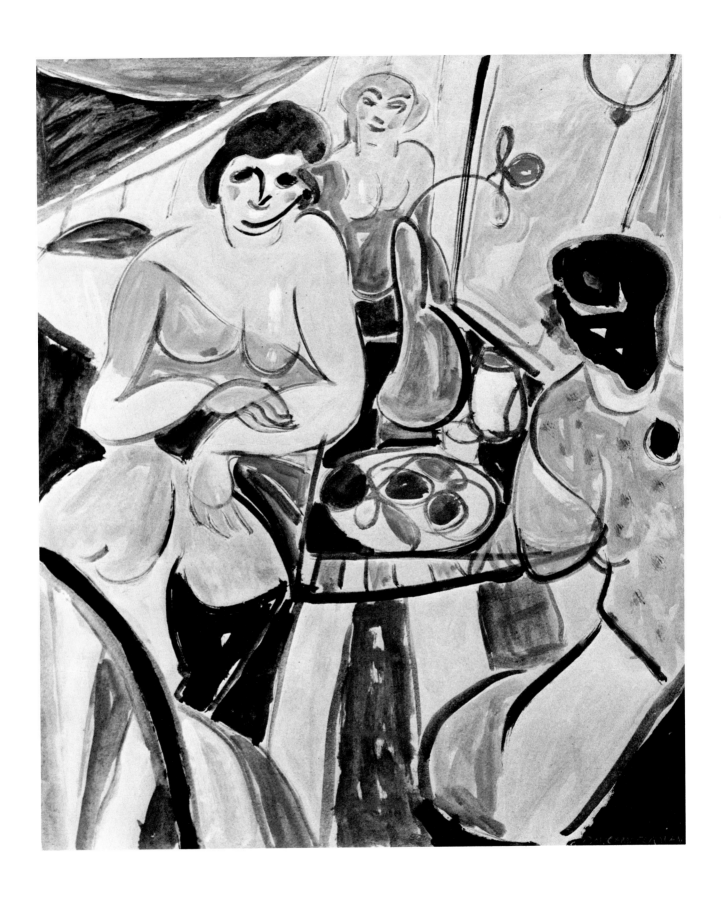

(7) Peter Camfferman. *Three Women at a Table*

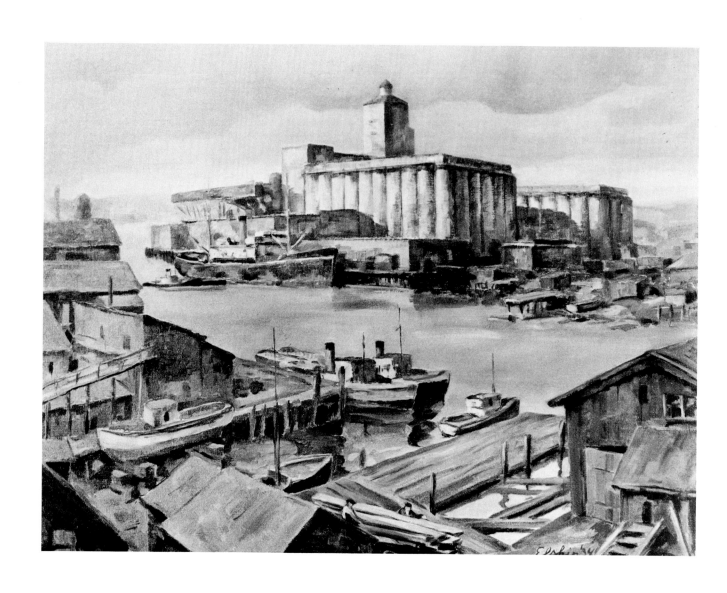

(8) Jacob Elshin. *Fisher Flour Mill*

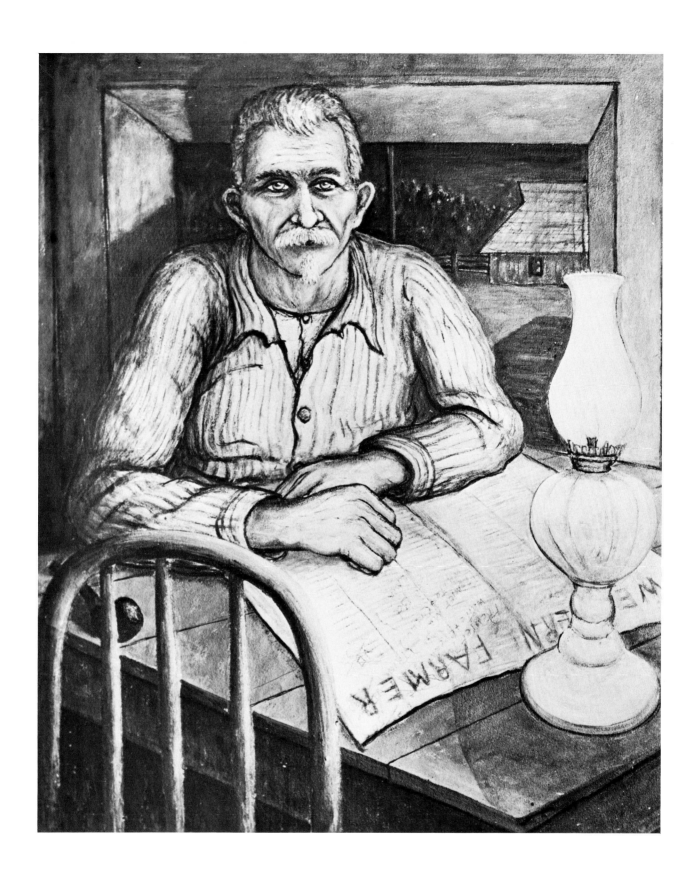

(9) Earl Fields. *Study Hour*

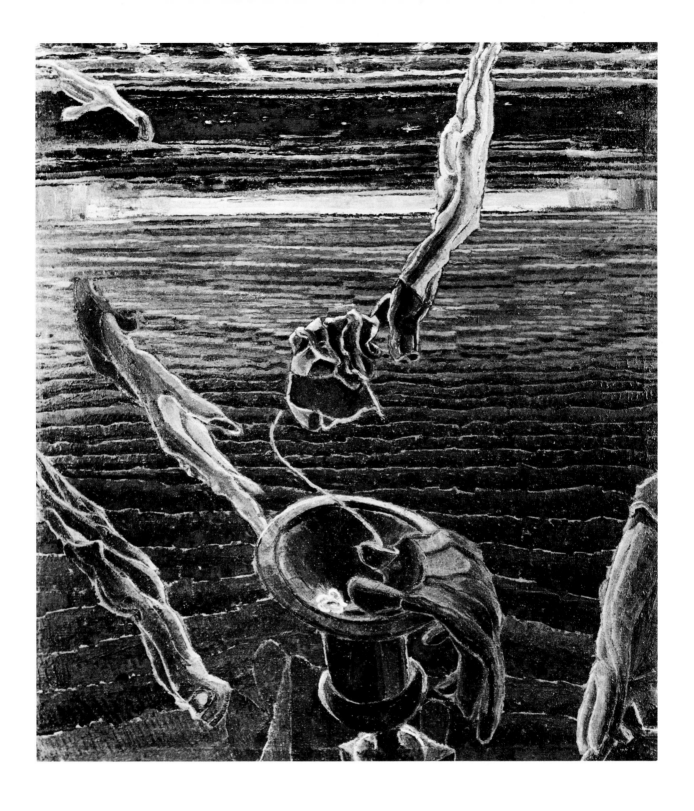

(11) Morris Graves. *Burial of the New Law*

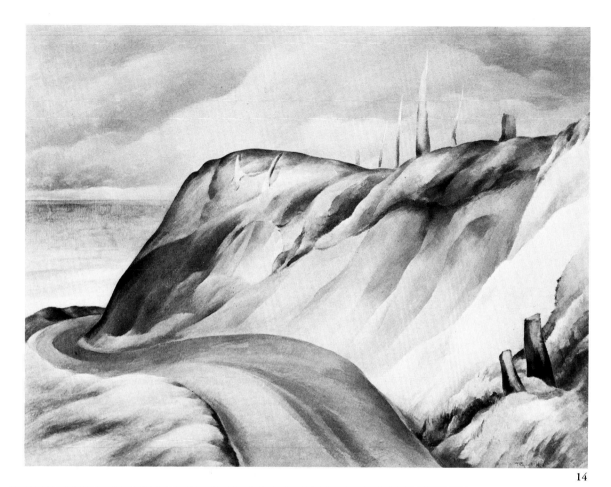

14

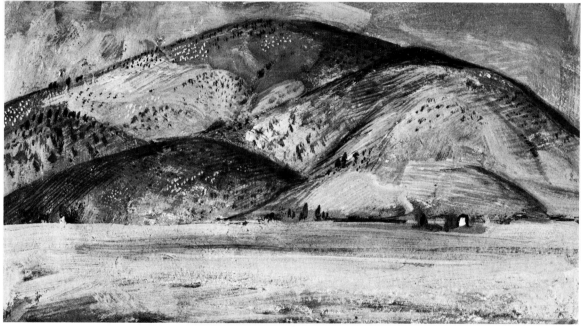

13

(13) Charles Heany. *Hills, Eastern Oregon*
(14) Raymond Hill. *Coast Road*

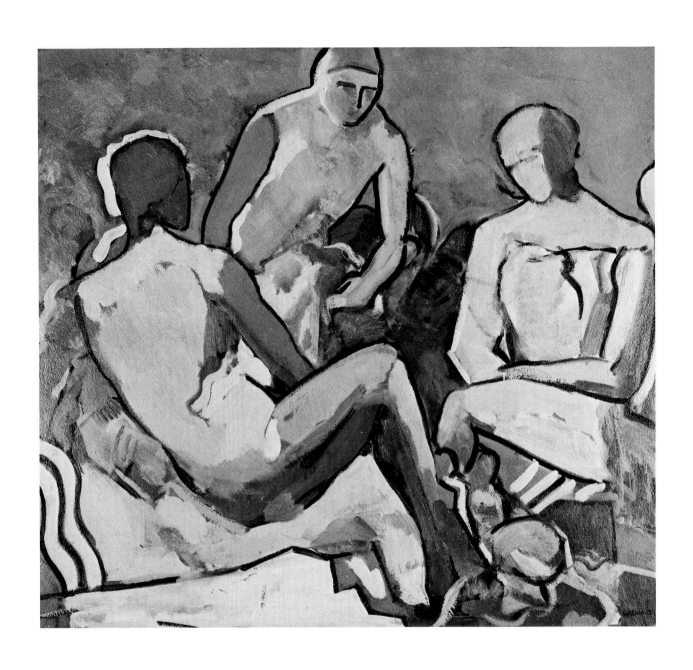

(15) Walter Isaacs. *Bathers*

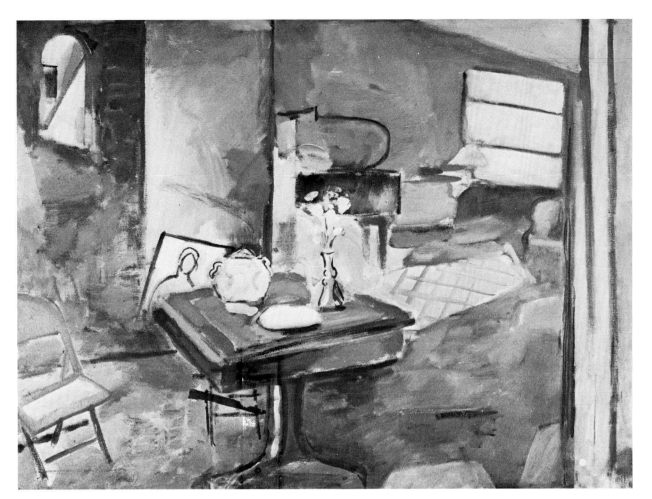

16

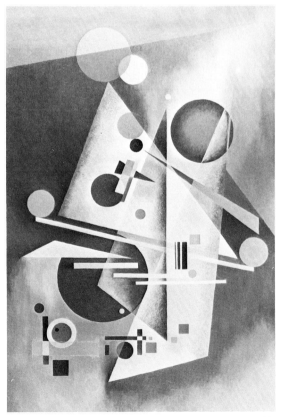

18

(16) Walter Isaacs. *Interior*
(18) Maude Kerns. *Composition No. 27*

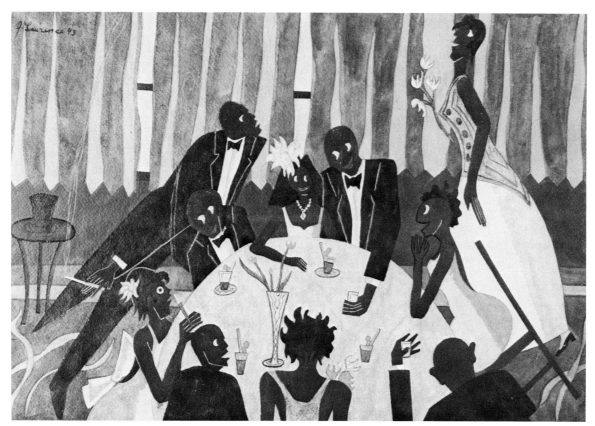

19

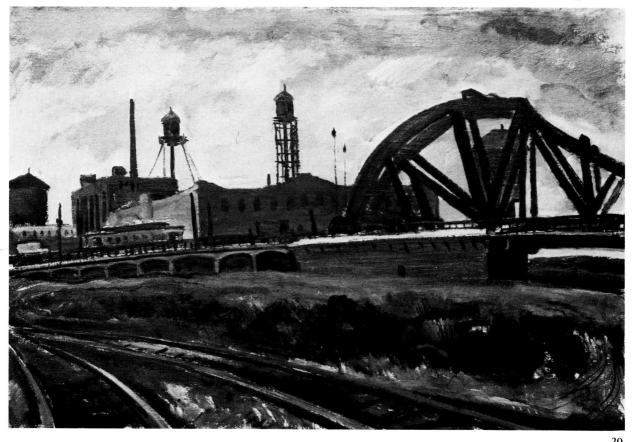

20

(19) Jacob Lawrence. *Harlem Society*
(20) David McCosh. *Iron Bridge*

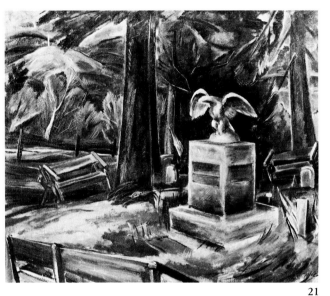

21

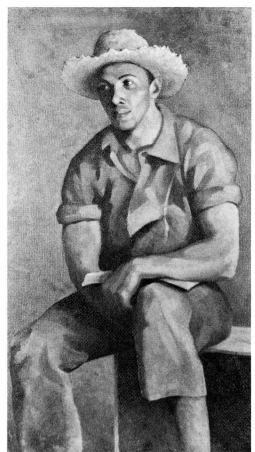

24

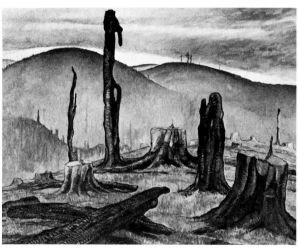

27

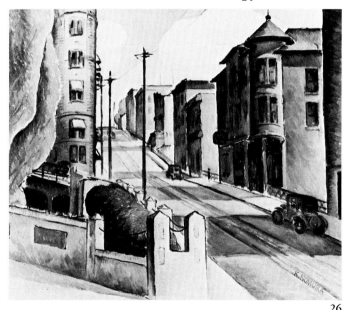

26

(21) David McCosh. *Landscape*
(24) Barney Nestor. *In Abraham's Bosom*
(26) Kenjiro Nomura. *Street*
(27) Ernest Norling. *Logged Off Land*

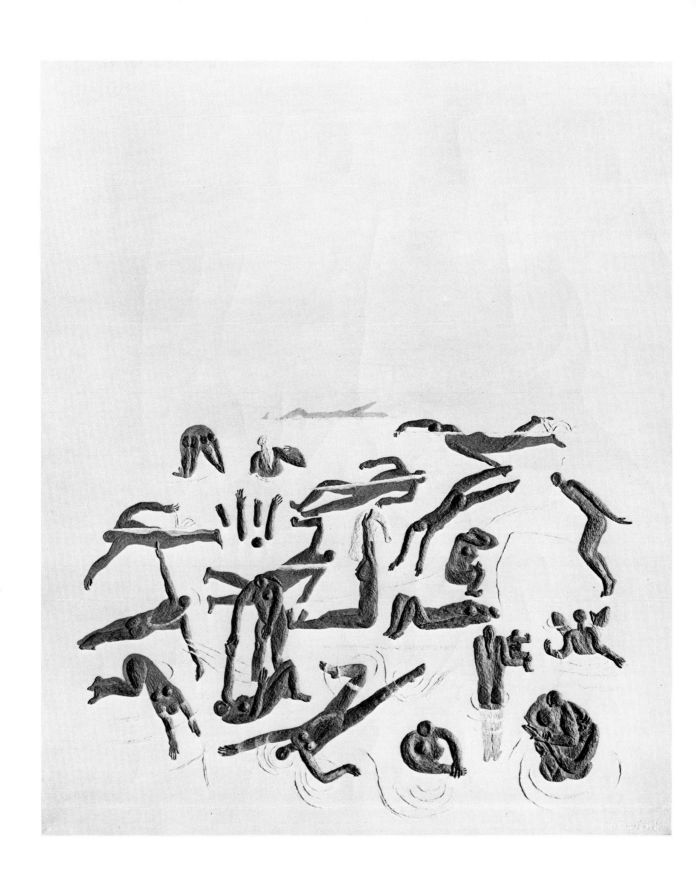

(28) Amédée Ozenfant. *La Belle Vie*

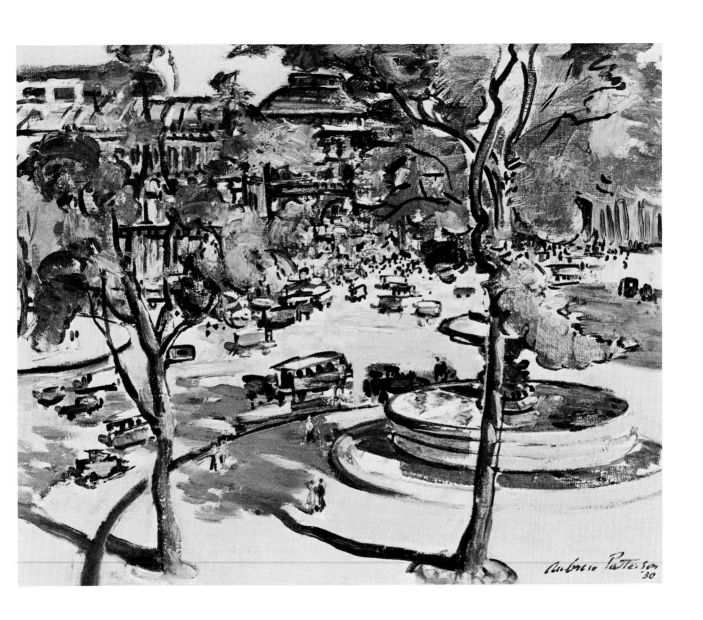

(30) Ambrose Patterson. *Place du Palais Royal*

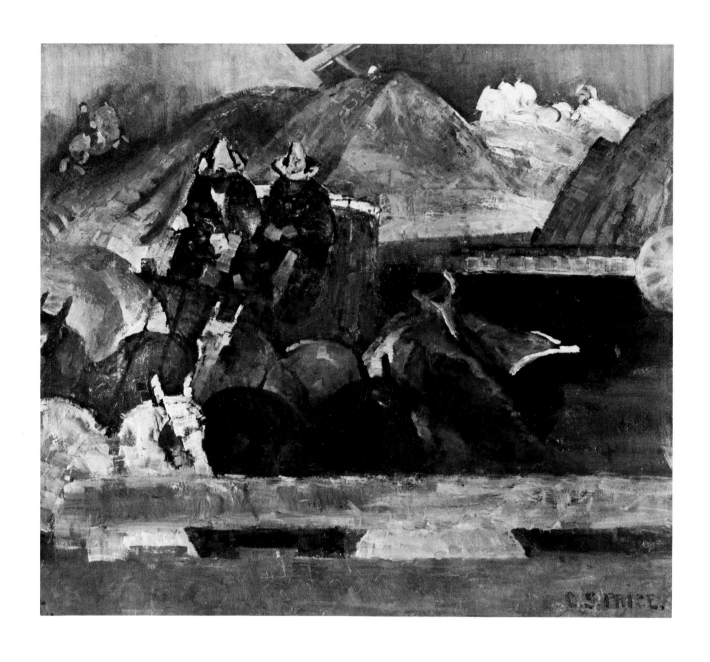

(33) C. S. Price. *The Mail Coach*

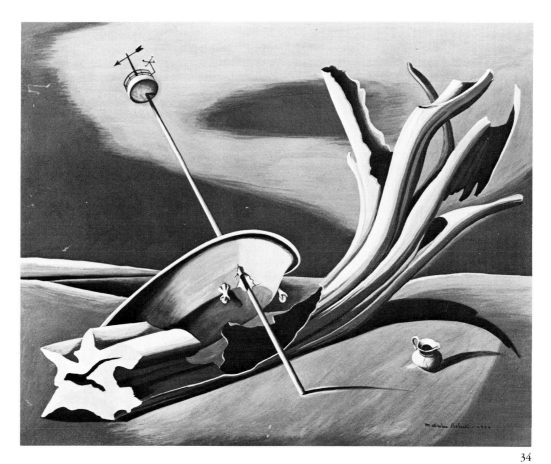

34

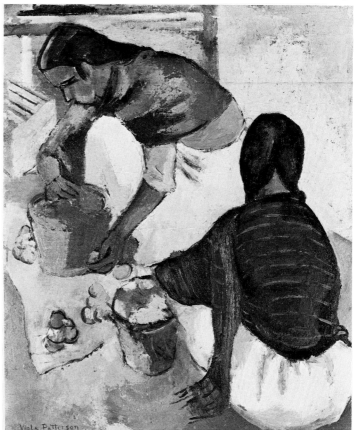

32

(32) Viola Patterson. *Two Mexican Women*
(34) Malcolm Roberts. *Drift No. 2*

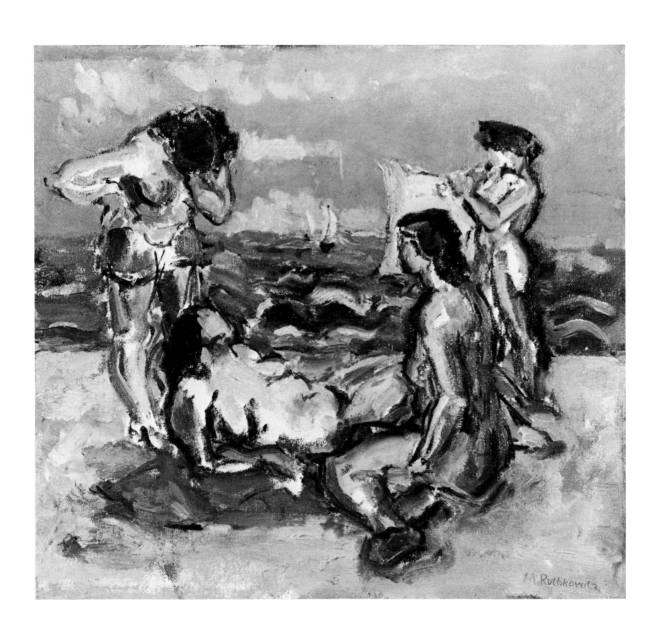

(35) Mark Rothko. *Beach Scene*

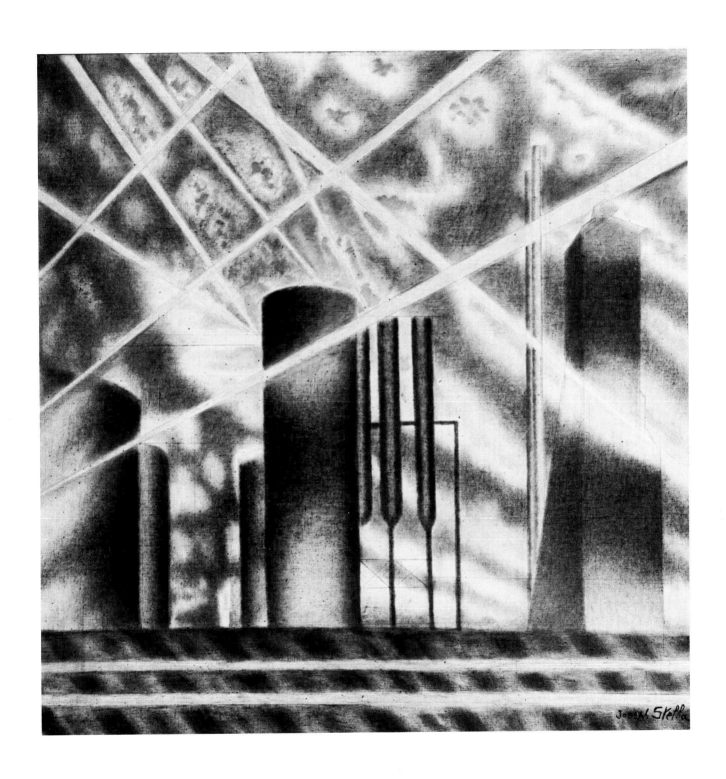

(36) Joseph Stella. *Factories at Night*

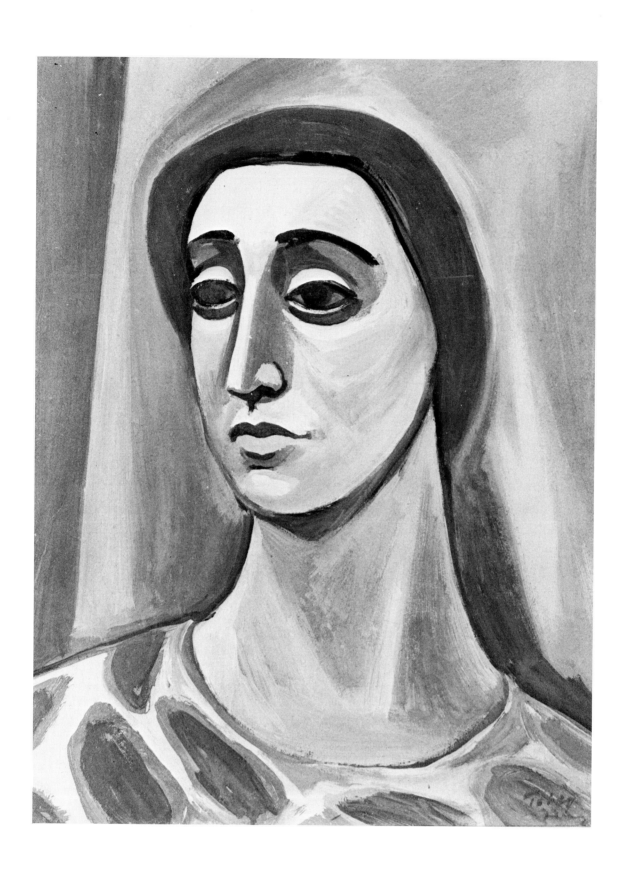

(37) Mark Tobey. *Head of a Woman*

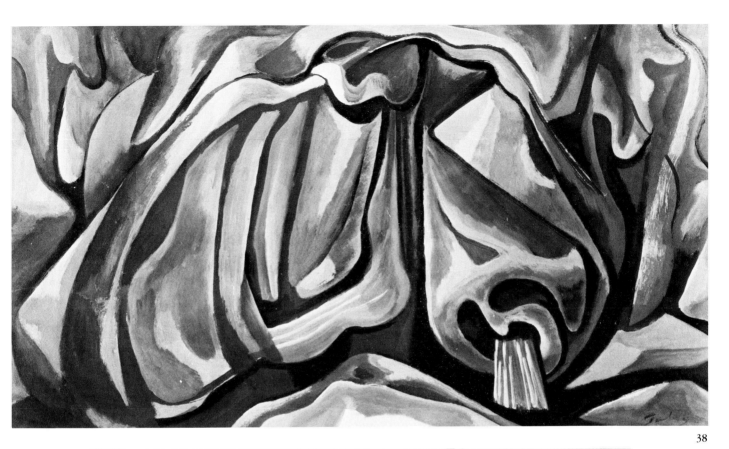

38

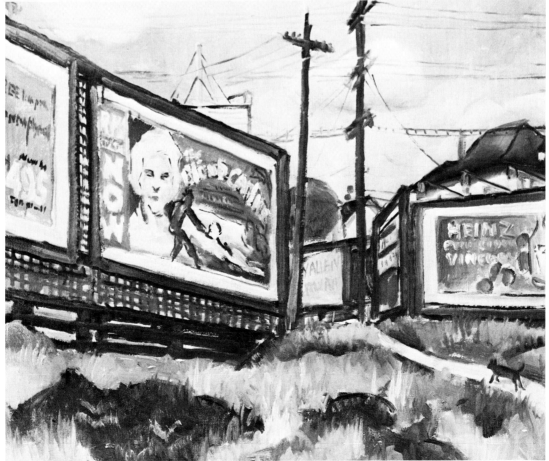

(38) Mark Tobey. *Moving Forms*
(39) Kamekichi Tokita. *Billboards*

39

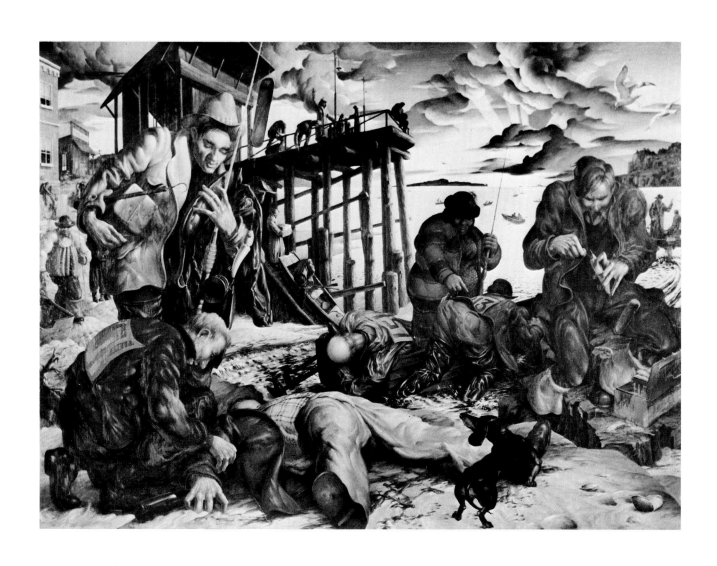

(43) Rudolph Zallinger. *Northwest Salmon Fishermen*

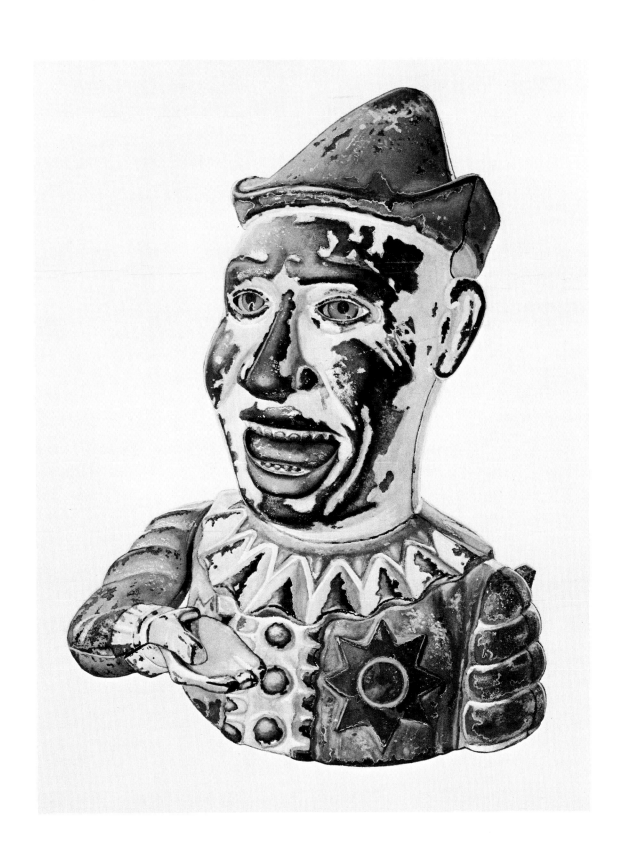

(44) Alf Bruseth. *Humpty Dumpty Coin Bank*

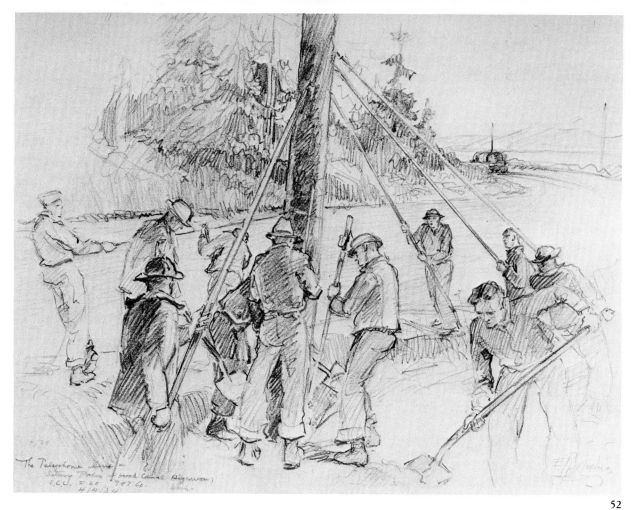

52

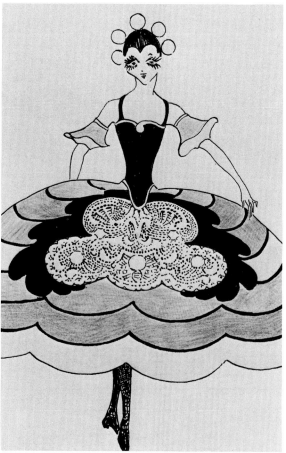

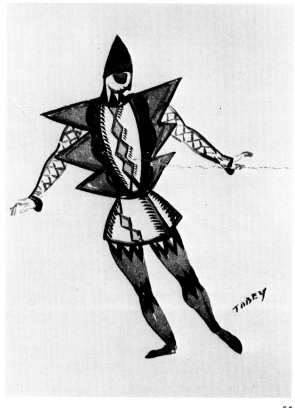

55

(47) Doriece Colle. *Costume for the Miller's Wife in "The Three-cornered Hat"*
(52) Ernest Norling. *The Telephone Line—Setting Poles*
(55) Mark Tobey. *Male Harlequin*

47

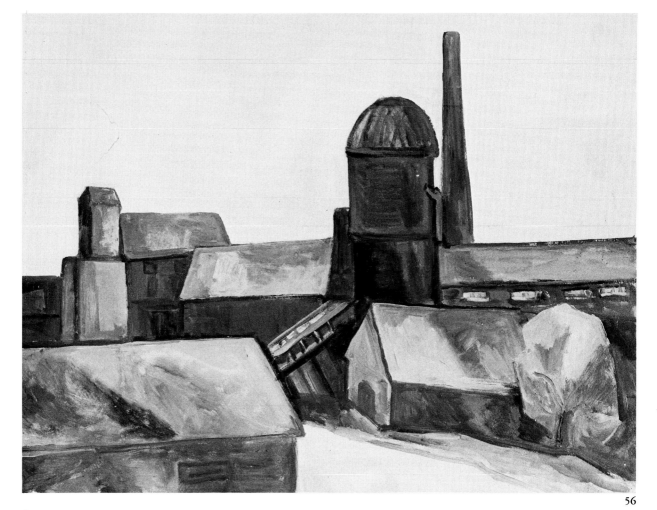

56

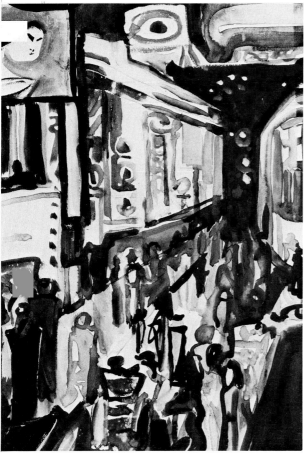

57

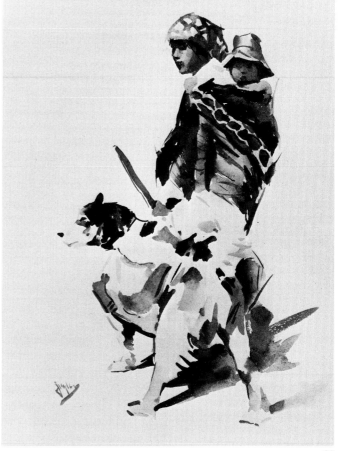

58

(56) Mark Tobey. *Mill*
(57) Mark Tobey. *San Francisco Street*
(58) Eustace Ziegler. *Squaw and Dog*

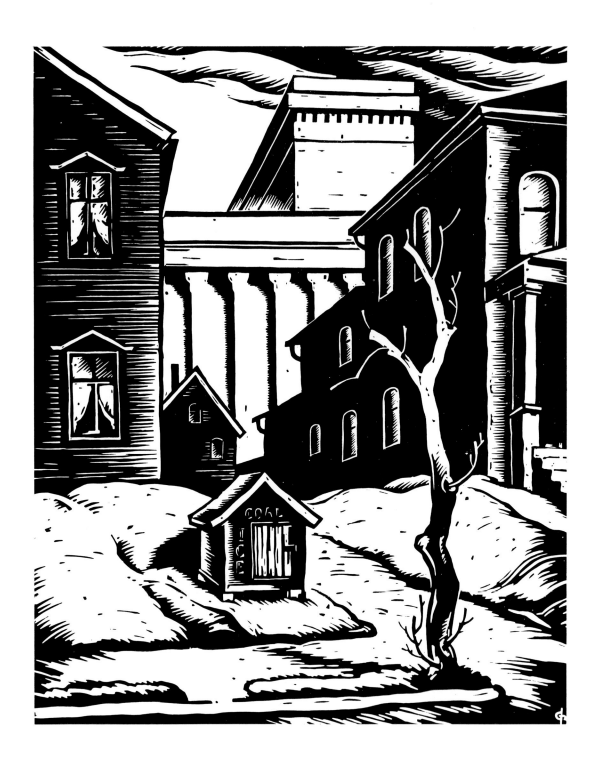

(59) G. Bakker. *Around the Courthouse*

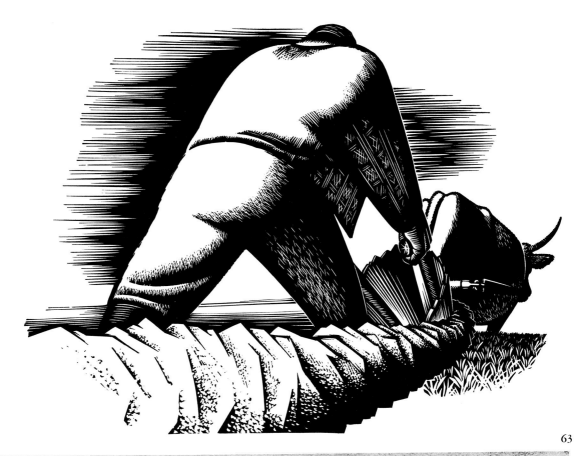

63

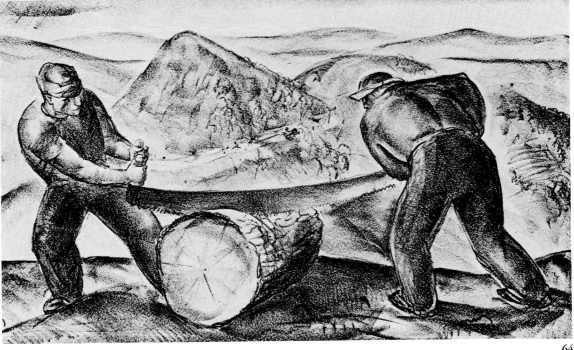

64

(63) Richard Correll. *Plowing* (Paul Bunyan Series)
(64) Raymond Creekmore. *C. C. C. Woodcutters*

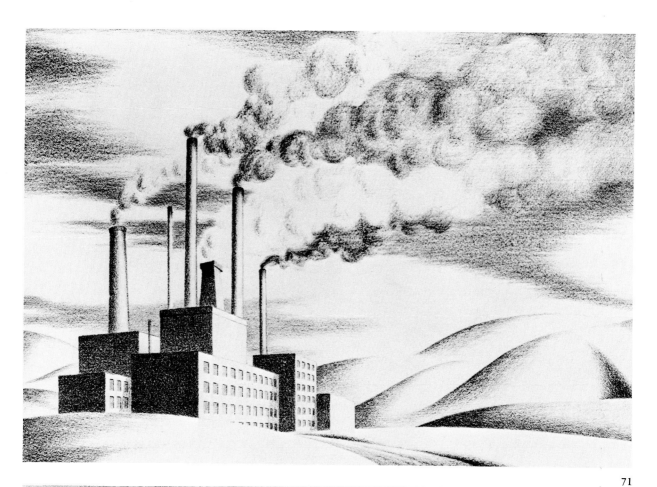

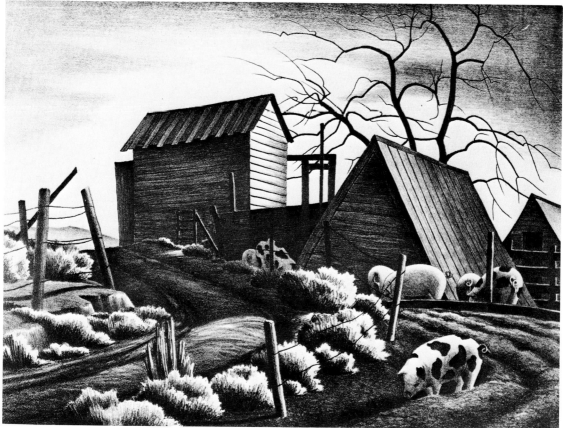

72

(71) Z. Vanessa Helder. *Factory Forms*
(72) Z. Vanessa Helder. *Old MacDonald's Farm*

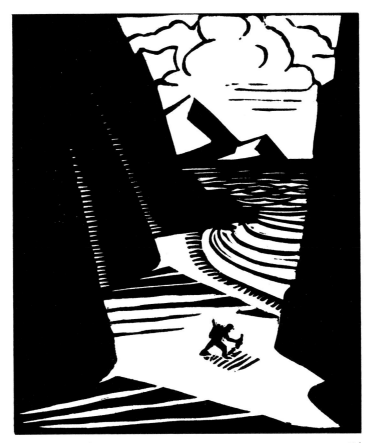

74

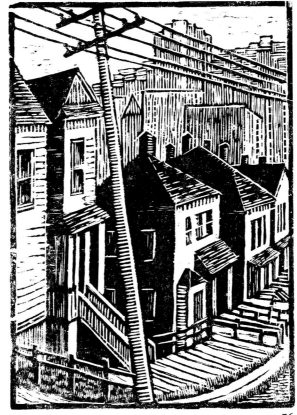

76

(74) Robert Bruce Inverarity. *Indians Gathering Bark*
(76) Catherine Nicholson. *Old and New Seattle*

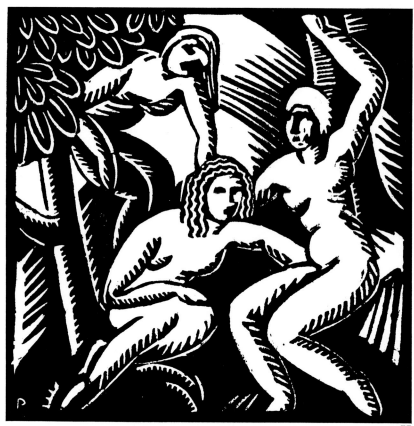

77

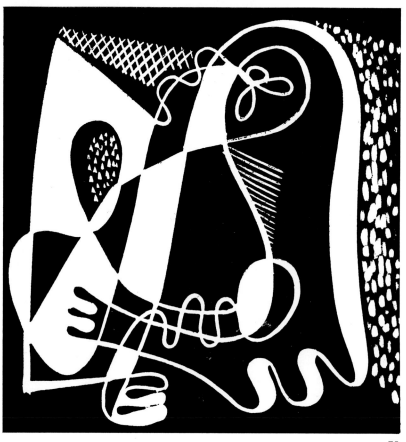

78

(77) Ruth Penington. *Composition*
(78) Ruth Penington. *No. 1*

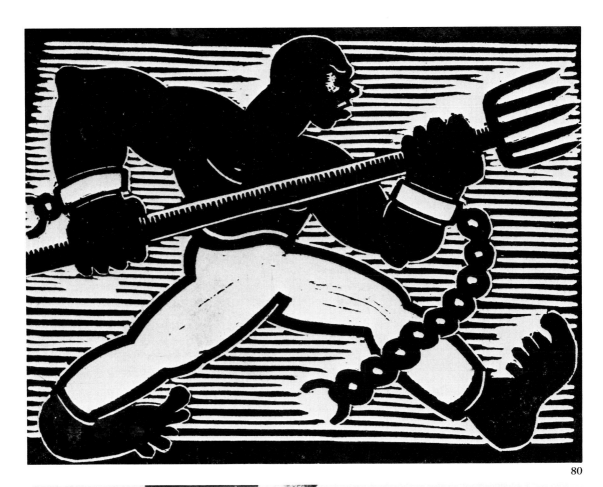

80

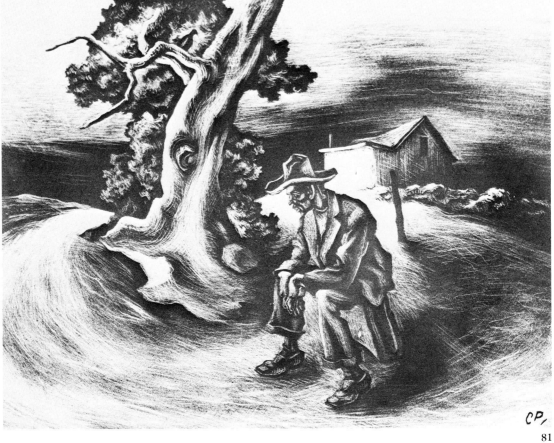

81

(80) Ralph Austin (Tony) Perez. *Negro Revolt*
(81) Charles Pollock. *Look Down That Road*

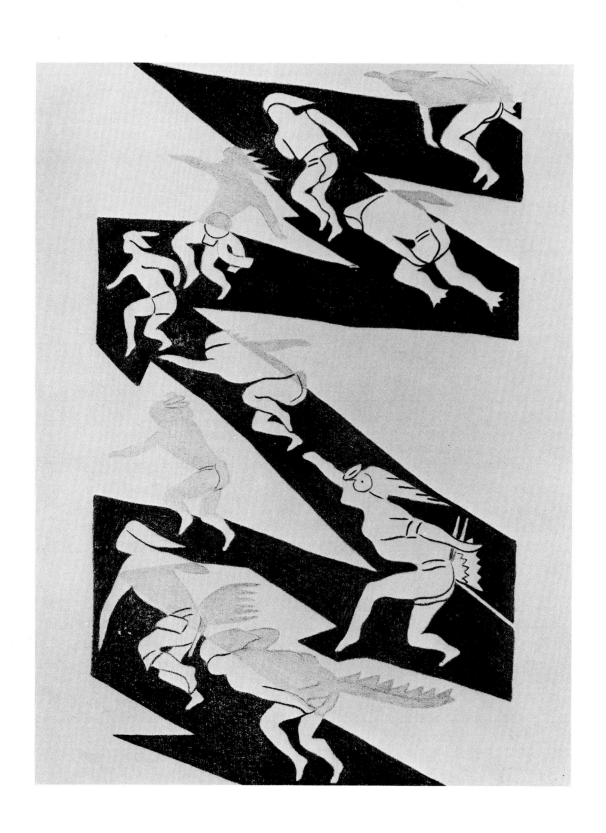

(88) Julius Twohy. *Speed Color and Action*

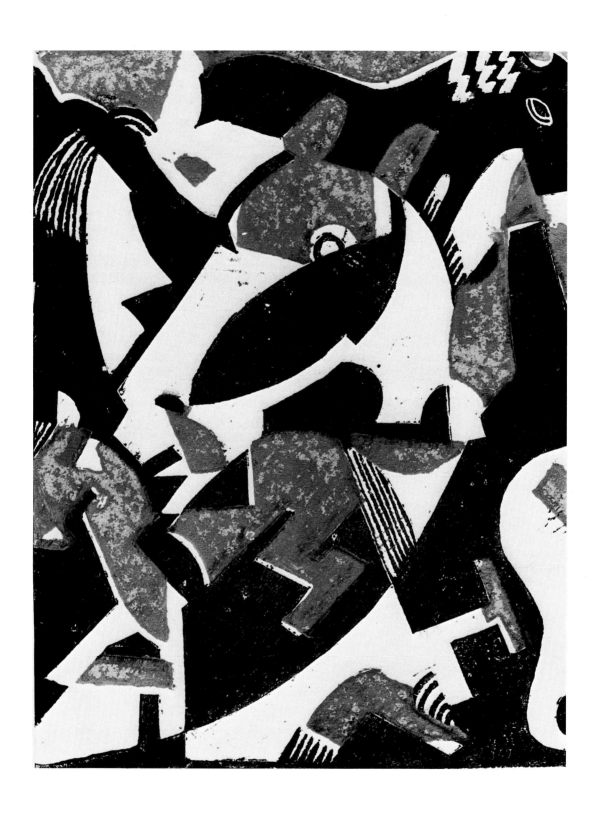

(91) Frances Wismer. *Gymkhana*

(92) Imogen Cunningham. *Portrait of Mme Ozenfant*

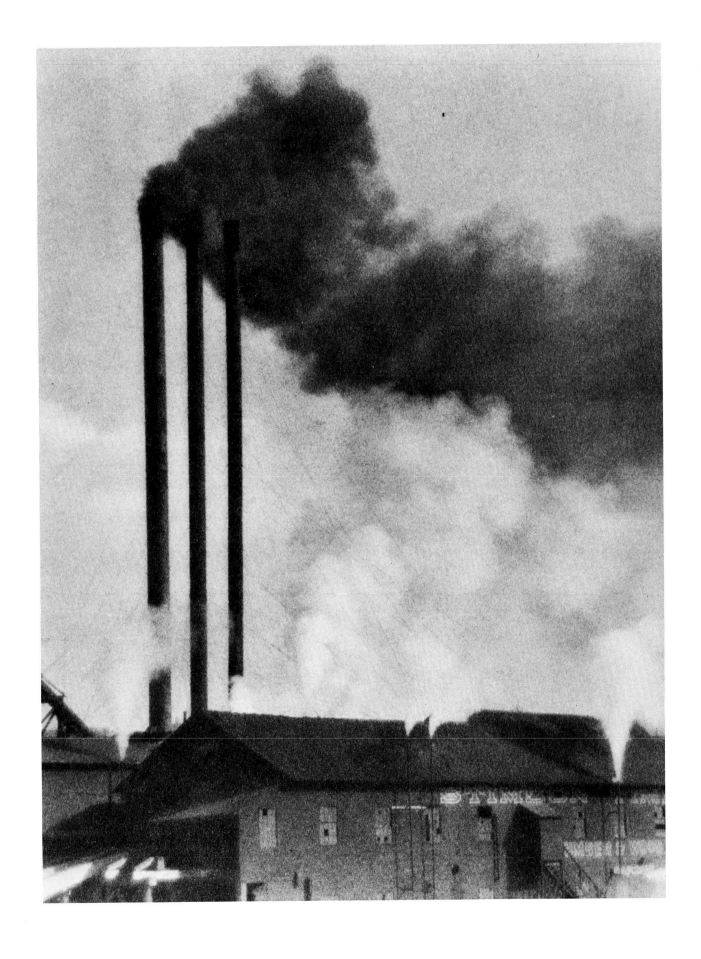

(104) Dr. Kyo Koike. Roof and three smokestacks

109

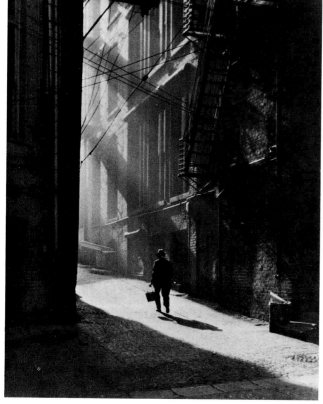

110

112

(109) Dr. Kyo Koike. Four planes, cumulus clouds
(110) Dr. Kyo Koike. Man in alley
(112) Minor White. View out a café window

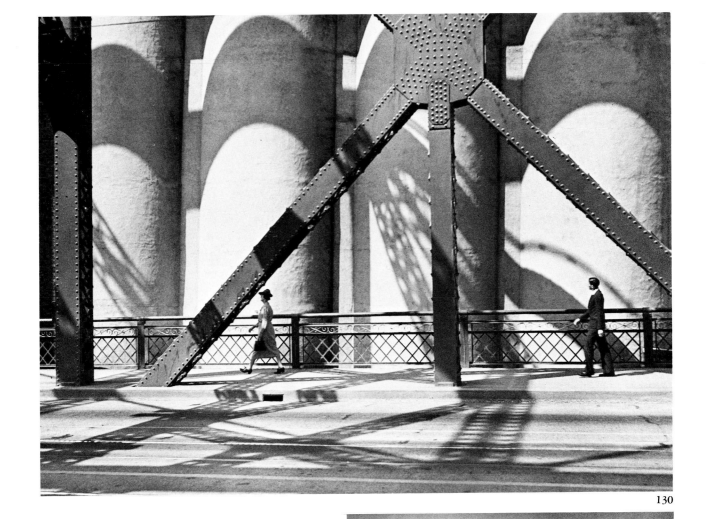

130

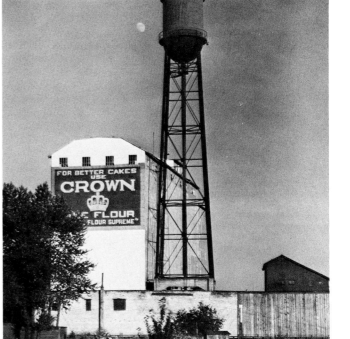

123

(123) Minor White. Water tower and factory
(130) Minor White. Grain elevator and bridge

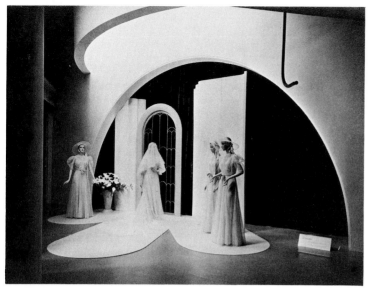

136

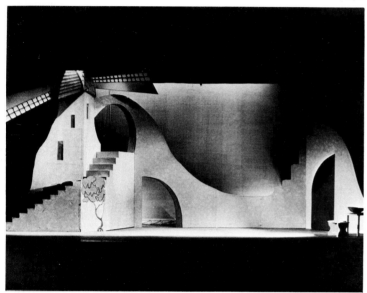

141

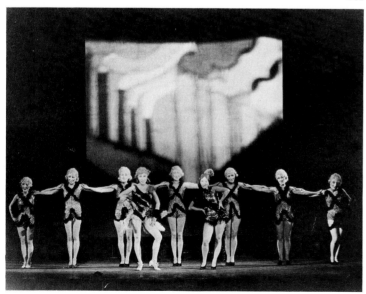

143

(136) Bridal display, store window
(141) John Ashby Conway. Set for *The Three-cornered Hat*
(143) John Ashby Conway and George McKay. *Epoch—An American Dance Symphony*

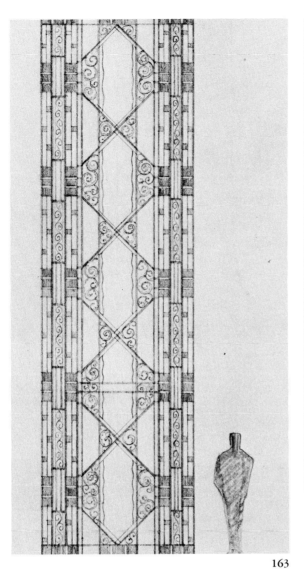

163

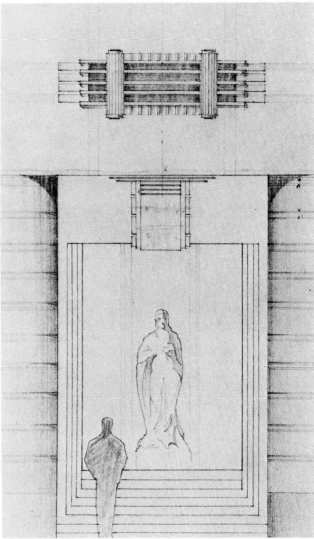

161

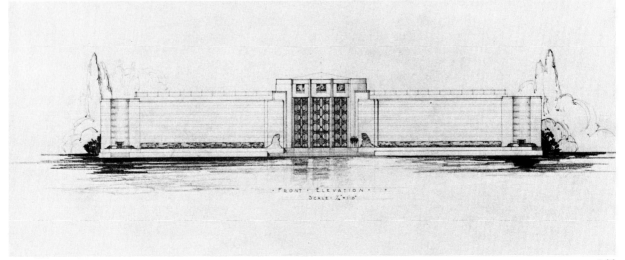

146

(146) Carl Gould. Seattle Art Institute, front elevation
(161) Carl Gould. Seattle Art Institute, view into north gallery
(163) Carl Gould. Seattle Art Institute, entry

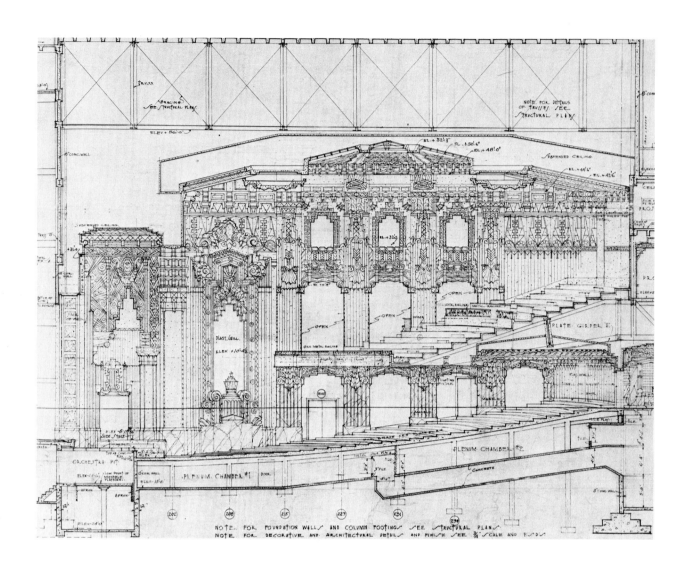

(176) B. Marcus Priteca. The Pantages Theater, longitudinal
section

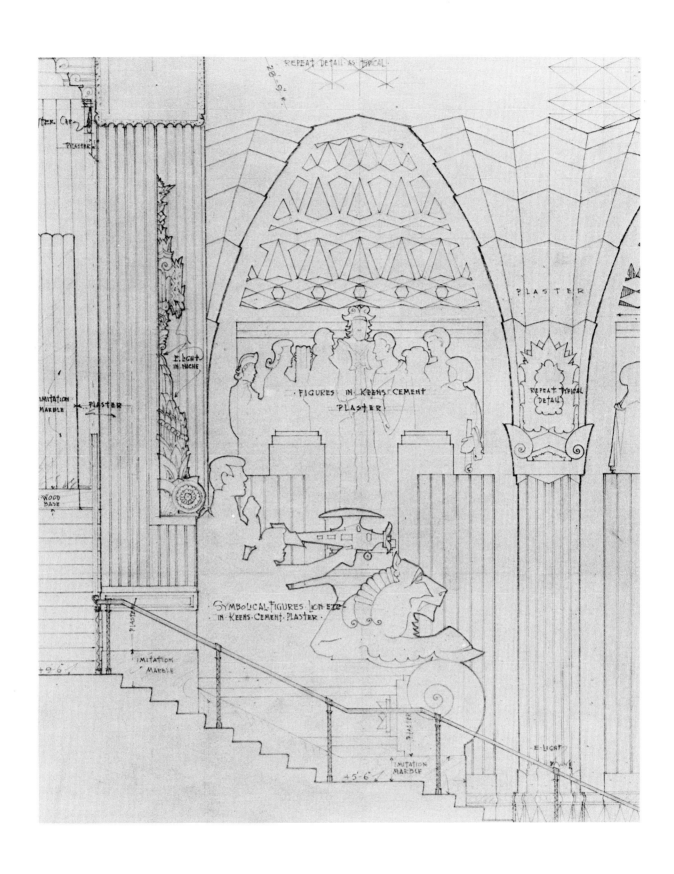

Within the drawing (labels):

REPEAT DETAIL AS TYPICAL

PLASTER

E. LIGHT IN NICHE

PLASTER

REPEAT TYPICAL DETAIL

IMITATION MARBLE

PLASTER

FIGURES IN KEENS CEMENT PLASTER

WOOD BASE

SYMBOLICAL FIGURES ICH ETC IN KEENS CEMENT PLASTER

IMITATION MARBLE

IMITATION MARBLE

E. LIGHT

(178) B. Marcus Priteca. The Pantages Theater, lobby, with sculpture

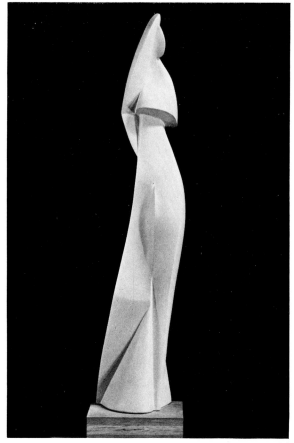

194

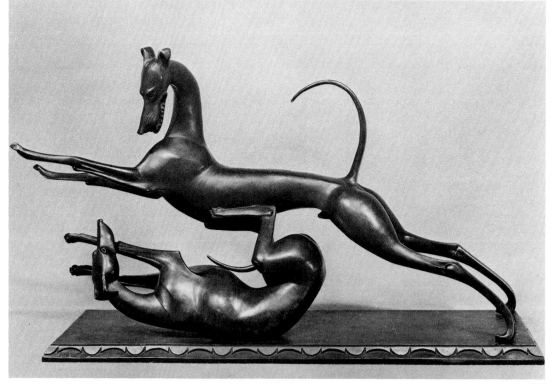

198

(194) Alexander Archipenko. *The Bride*
(198) Hunt Diederich. *Greyhounds Playing*

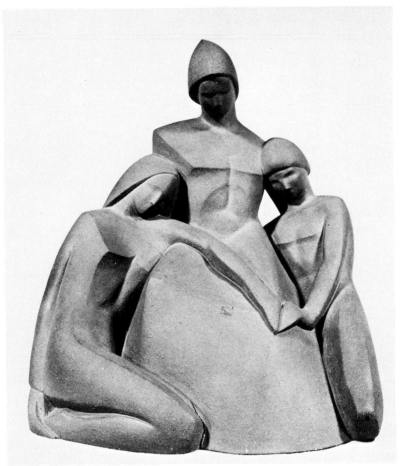

203

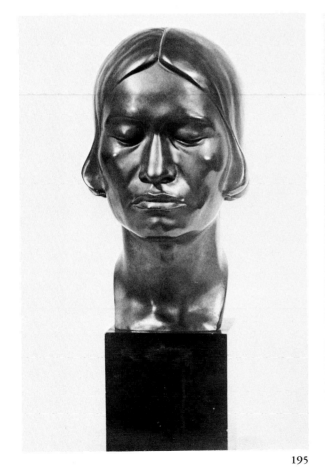

195

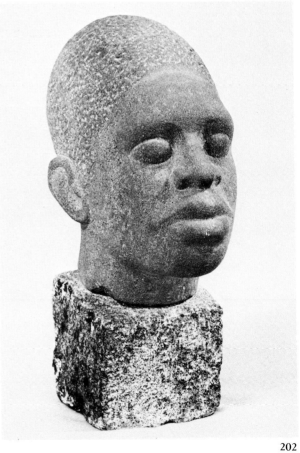

202

(195) George Blodgett. *José Rey Calavasa*
(202) Edna Guck, *Head of a Negro Boy*
(203) David Lemon. *Mother and Children*

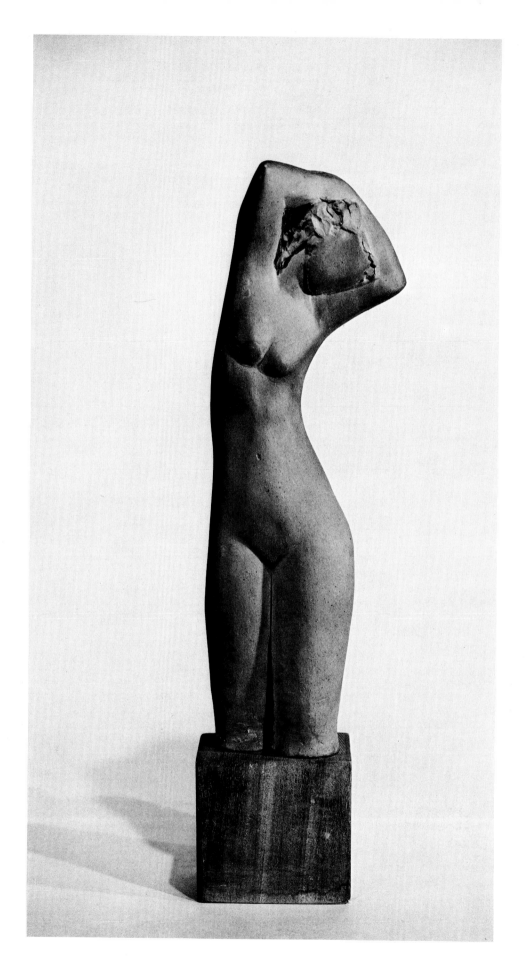

(206) Viola Patterson. *Female Torso*

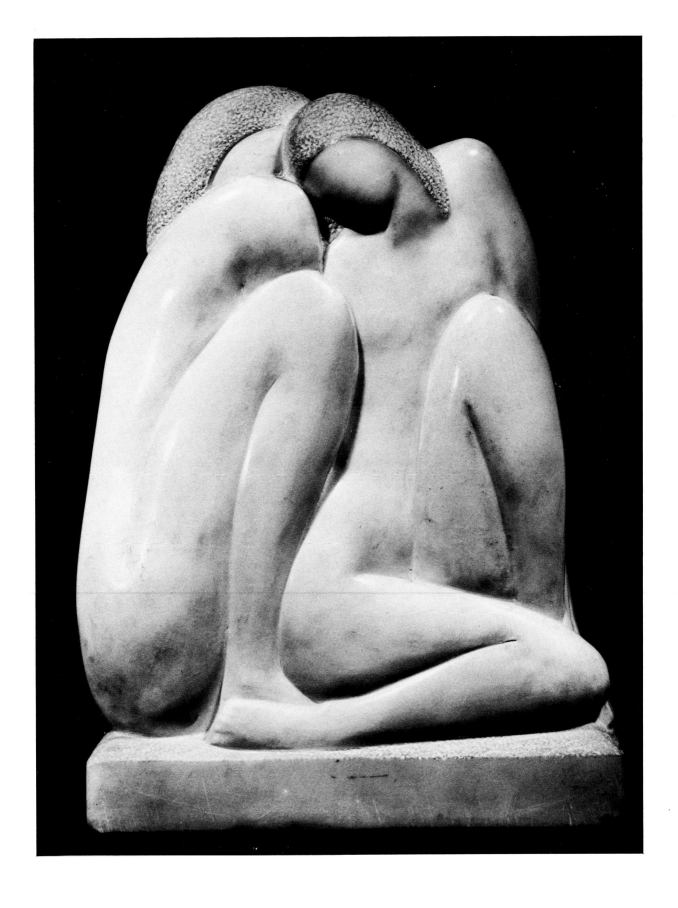

(209) Dudley Pratt, *Group*

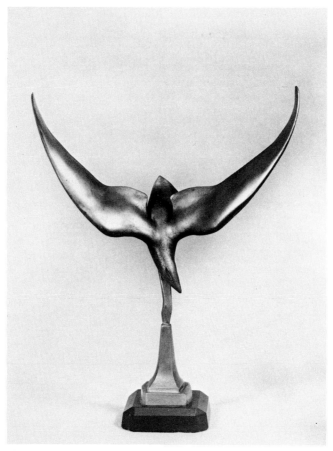

210

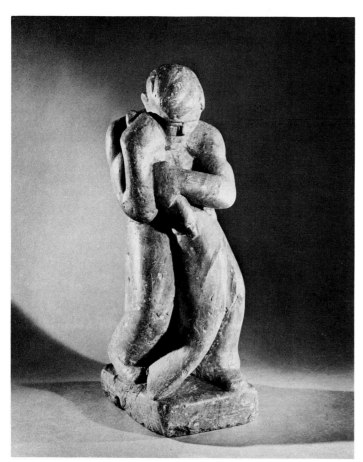

213

(210) Dudley Pratt. *Seagull*
(213) George Tsutakawa. *Northwest Fisherman (Self-Portrait)*

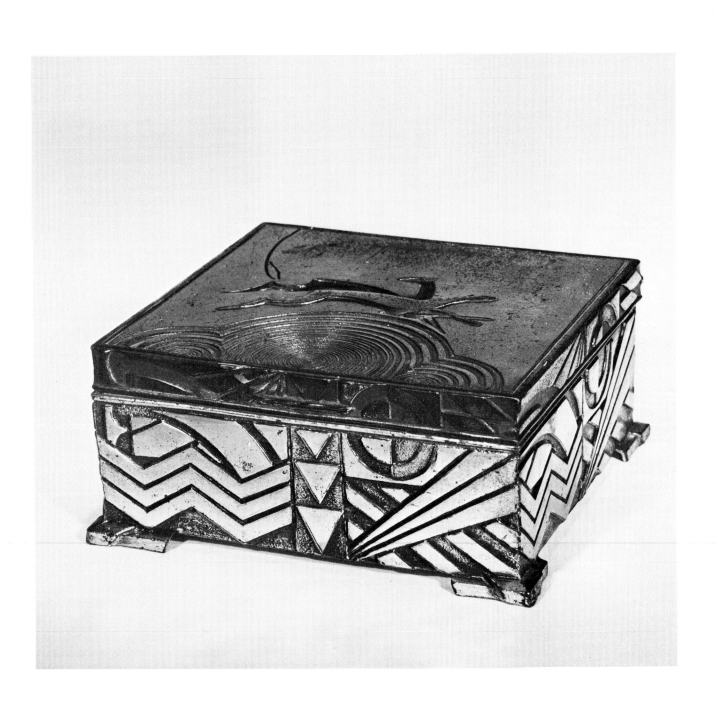

(230) Chrome-plated metal box, Japanese origin

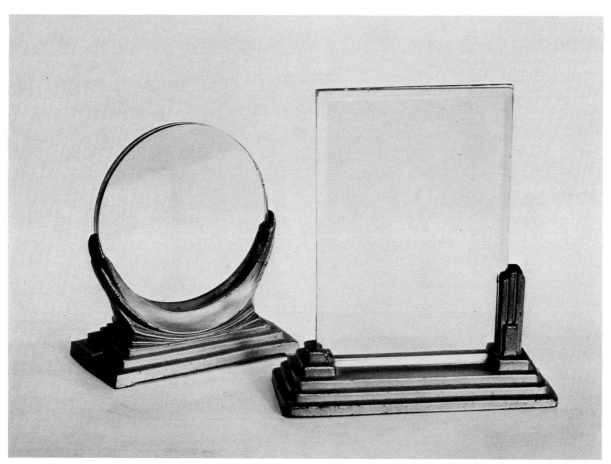

232

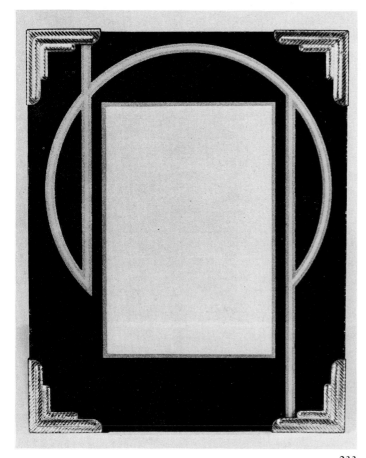

233

(232) Pair of photograph mounts
(233) Painted glass picture frame

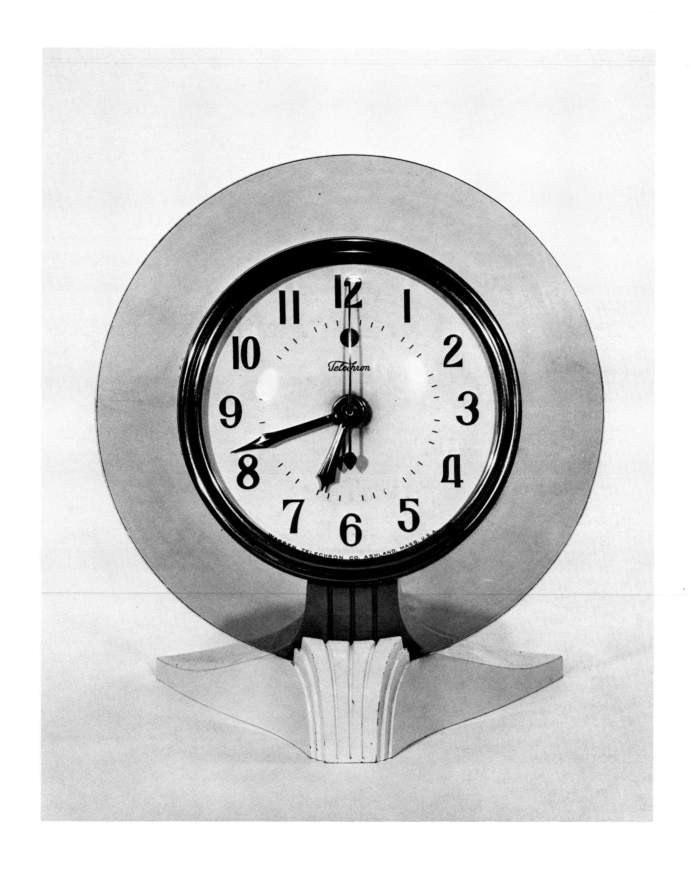

(235) Telechron electric clock

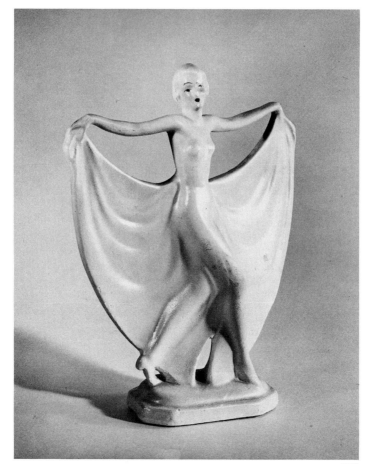

240

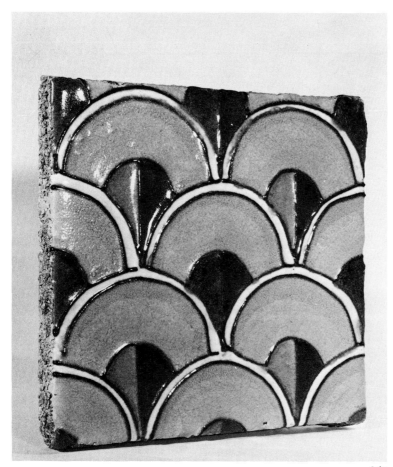

240

(237) Statuette of woman dancer
(240) Ceramic tile

241

242

(241) George Tsutakawa. Ceramic tile
(242) Perfume atomizer

246

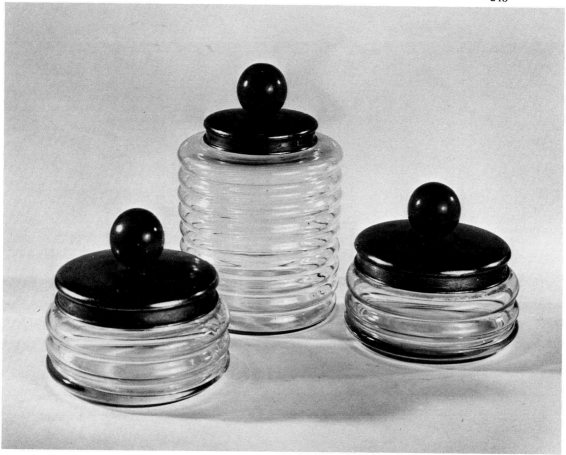

244

(244) Three vanity table jars
(246) Pottery vase with painted peacocks

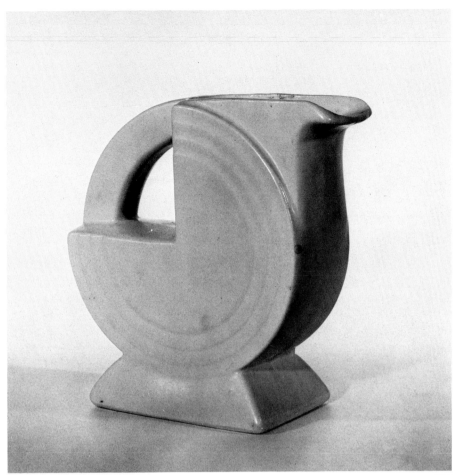

250

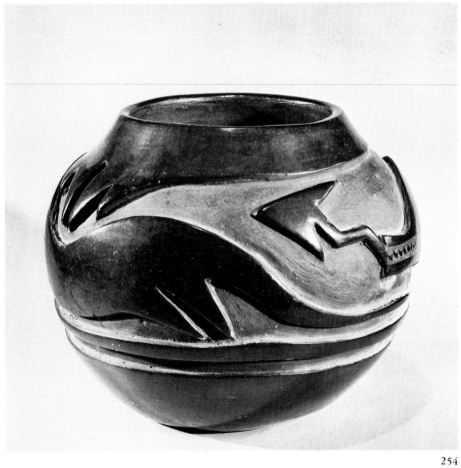

254

(250) Pitcher-shaped vase
(254) Black pottery pot, Southwest American Indian

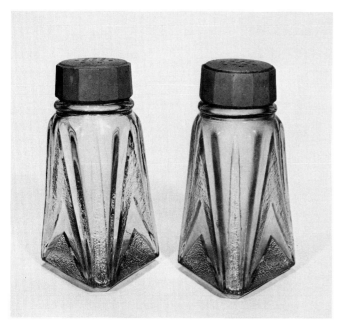

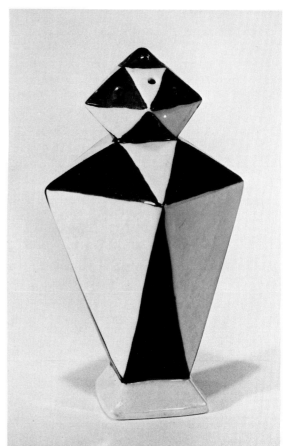

256

257

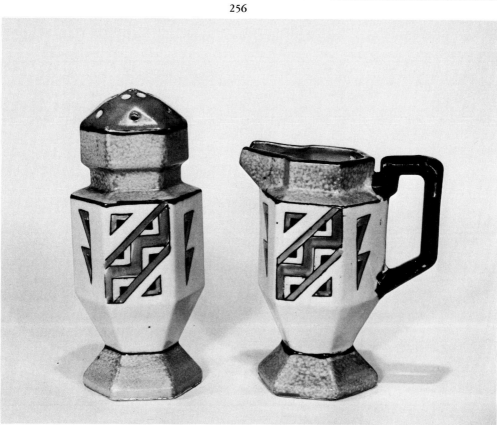

260

(256) Green glass salt and pepper shakers
(257) Ceramic salt shaker, Japanese origin
(260) Ceramic creamer and sugar shaker, Japanese origin

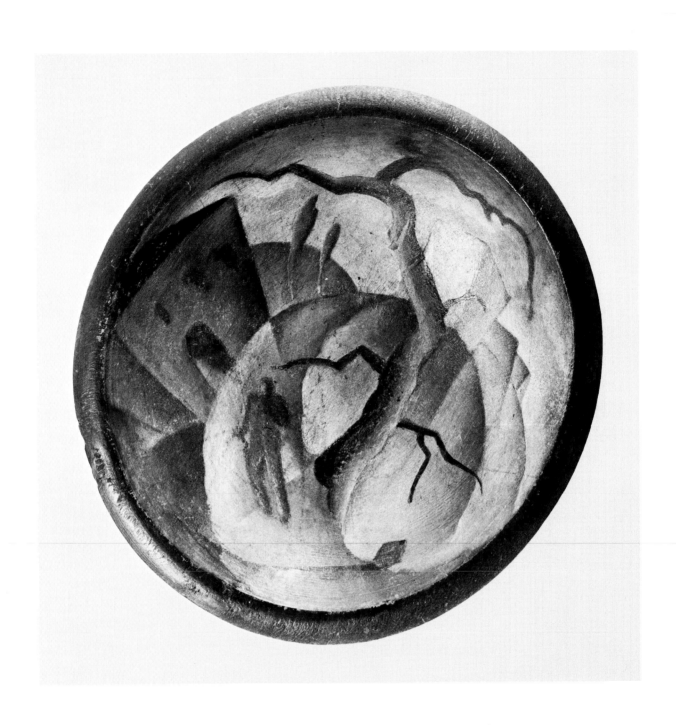

(263) George Tsutakawa. Painted wood bowl

266

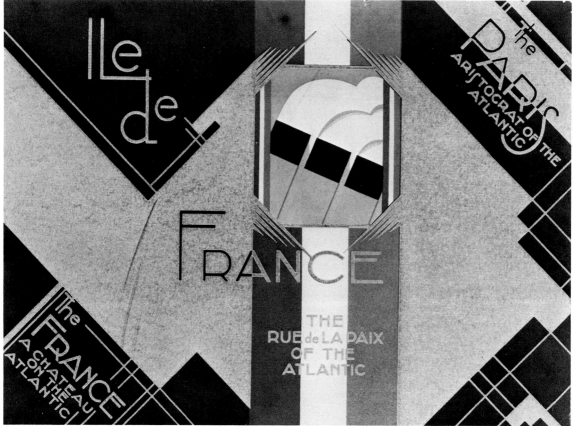

267

(266) Blue glass divided dish, Japanese origin
(267) French Line booklet, *The Longest Gangplank in the World*

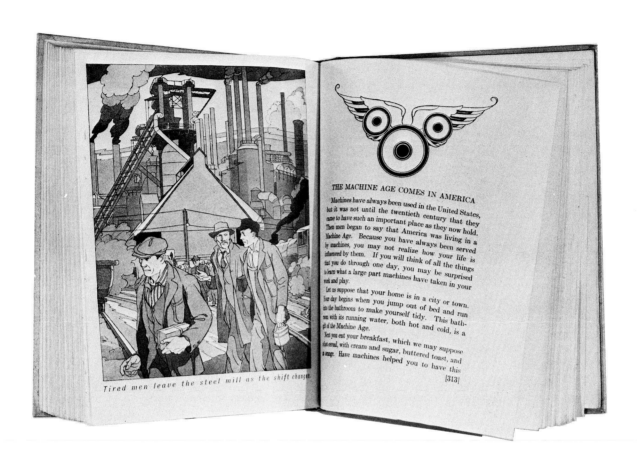

Tired men leave the steel mill as the shift changes

THE MACHINE AGE COMES IN AMERICA

Machines have always been used in the United States, but it was not until the twentieth century that they came to have such an important place as they now hold. Then men began to say that America was living in a Machine Age. Because you have always been served by machines, you may not realize how your life is influenced by them. If you will think of all the things that you do through one day, you may be surprised to learn what a large part machines have taken in your work and play.

Let us suppose that your home is in a city or town. Your day begins when you jump out of bed and run into the bathroom to make yourself tidy. This bathroom with its running water, both hot and cold, is a gift of the Machine Age.

Next you eat your breakfast, which we may suppose is hot cereal, with cream and sugar, buttered toast, and an orange. Have machines helped you to have this

[313]

(268) Edna McGuire. History text, *A Full-grown Nation*

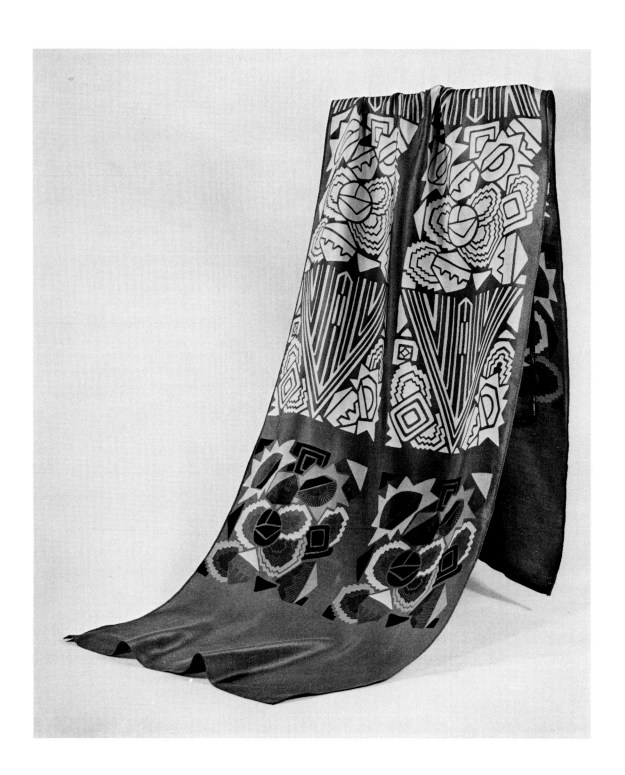

(276) Printed rayon scarf

General

American Abstract Artists. *The World of Abstract Art.* New York: George Wittenborn, 1957.

Art in Our Time. New York: Museum of Modern Art, 1939.

Art in Progress. New York: Museum of Modern Art, 1944.

Barr, Alfred H., Jr., et al. *American Art of the 20's and 30's.* 1932. Reprint. New York: Arno Press for the Museum of Modern Art, 1969.

Baur, John I. H. *Revolution and Tradition in American Art.* Cambridge, Mass.: Harvard University Press, 1951.

Boswell, Peyton, Jr. *Modern American Painting.* New York: Dodd, Mead & Company, 1939.

Cahill, Holger. *New Horizons in American Art.* New York: Museum of Modern Art, 1936.

————, et al. *American Art Today: New York World's Fair.* [New York]: National Art Society, 1939.

Congdon, Don, ed. *The Thirties: A Time to Remember.* New York: Simon & Schuster, 1962.

Contemporary Art: Official Catalog . . . Golden Gate International Exposition. [San Francisco]: San Francisco Bay Exposition Company, 1939.

Contemporary Art of 79 Countries (I.B.M. Exhibit at New York World's Fair, 1939). [New York]: International Business Machines Corporation, 1939.

Decorative Arts: Official Catalog . . . Golden Gate International Exposition. [San Francisco]: San Francisco Bay Exposition Company, 1939.

Garver, Thomas H., et al. *Just Before the War.* New York: October House, 1968.

Goodrich, Lloyd, and John Baur. *American Art of Our Century.* New York: Praeger, 1961.

Merkin, Richard. *The Jazz Age: As Seen through the Eyes of Ralph Barton, Miguel Covarrubias, and John Held Jr.* Providence: Museum of Art, Rhode Island School of Design, 1968.

Pagano, Grace. *Catalogue of the Encyclopaedia Britannica Collection of Contemporary American Paintings.* Chicago: Encyclopaedia Britannica, 1945.

Pearson, Ralph M. *The Modern Renaissance in American Art.* New York: Harper & Brothers, 1954.

[Rebay, Hilla]. *Second Enlarged Catalogue of the Solomon R. Guggenheim Collection of Non-Objective Paintings.* New York: 1937.

Ringel, Fred J., ed. *America as Americans See It.* New York: Literary Guild, 1932.

Rose, Barbara. *American Art since 1900.* New York: Praeger, 1967.

Government Art Programs

Bruce, Edward, and Forbes Watson. *Art in Federal Buildings, Volume 1: Mural Designs, 1934–36.* Washington, D.C.: Art in Federal Building, Inc., 1936.

Christensen, Erwin O. *The Index of American Design.* New York: Macmillan Co., 1959.

McDonald, William F. *Federal Relief Administration and the Arts.* Columbus: Ohio State University Press, 1969.

O'Connor, Francis V. *Federal Support for the Visual Arts: The New Deal and Now.* Greenwich, Conn.: New York Graphic Society, 1969.

Short, C. W., and R. Stanley-Brown. *Public Buildings: Architecture under the Public Works Administration 1933 to 1939.* Washington, D.C.: United States Government Printing Office, 1939.

Design and Principles of Design

Cheney, Sheldon. *Art and the Machine.* New York: Whittlesey House, 1936.

Dow, Arthur W. *Composition.* Garden City, N.Y.: Doubleday, Doran and Co., 1929.

Frankl, Paul T. *Form and Reform: A Practical Handbook of Modern Interiors.* New York: Harper & Brothers, 1930.

————. *New Dimensions.* New York: Brewer & Warren, 1928

Gordon, Jan. *Painting for Beginners.* New York: Halcyon House, 1939.

Gropius, Walter. *Scope of Total Architecture.* 1937–47. Reprint. New York: Collier Books, 1962.

Hambidge, Jay. *The Elements of Dynamic Symmetry.* 1926. Reprint. New York: Dover Publications, 1967.

————. *Practical Applications of Dynamic Symmetry.* New York: Devin-Adair, 1932.

Hillier, Bevis. *Art Deco.* London and New York: Studio Vista, 1968.

————. *The World of Art Deco.* New York: E. P. Dutton and Co., 1971.

Hitchcock, Henry-Russell, and Philip Johnson. *The International Style: Architecture since 1922.* New York: W. W. Norton & Co., 1932.

Teague, Walter Dorwin. *Design This Day: The Technique of Order in the Machine Age.* New York: Harcourt, Brace & Company, 1940.

Wingler, Hans Maria. *The Bauhaus.* Cambridge, Mass.: MIT Press, 1969.

Northwest Conditions, Activities, and Artists

Ambrose Patterson. Seattle: Seattle Art Museum, 1961.

American Art Annual. Annual 1911-37; triennial 1938/41 on.

Appleton, Marion Brymner, ed. *Who's Who in Northwest Art.* Seattle: Frank McCaffrey, 1941.

Calhoun, Anne H. *A Seattle Heritage.* Seattle: Lowman & Hanford, 1942.

Jackson, Jessee, Hooverville's Mayor. "The Story of Hooverville." Unpublished MS, University of Washington Library, 1935.

Morgan, Murray. *Skid Road: Seattle—Her First Hundred Years.* Revised ed. 1951. New York: Ballantine Books, 1960.

Portland Art Museum. *C. S. Price.* Portland, Ore.: Portland Art Association, 1951.

Proceedings of the Pacific Arts Association. [Palo Alto, Calif.: Stanford University Press], 1926–40.

Reed, Gervais. *Walter F. Isaacs.* Seattle: Henry Gallery, University of Washington, 1965.

Roy, Donald Francis. "Hooverville: A Study of Homeless Men in Seattle." Master's thesis, University of Washington, 1935.

Seitz, William C. *Mark Tobey.* New York: Museum of Modern Art, 1962.

Some Work of the Group of Twelve. [Seattle]: Frank McCaffrey, 1937.

Tobey's 80: A Retrospective. Seattle: Seattle Art Museum and University of Washington Press, 1970.

The Town Crier. Seattle. 3 September 1910–3 November 1937.

Wight, Frederick, et al. *Morris Graves.* Berkeley: University of California Press, 1965.

Colophon

The text of this book was set by photocomposition in various sizes of Garamond No. 3. The book was printed on Warren's Flokote, 80 lb. The cover of the paperbound edition is Radiant Kote 10 pt. Composition and offset lithography by the University of Washington Department of Printing. The cloth-bound edition was bound by Lincoln and Allen, Portland, Oregon.

Designed by Douglas Wadden